Lived Experience

Lived Experience
Reflections on LGBTQ Life

Delphine Diallo

THE
NEW
PRESS

© 2020 by Delphine Diallo
Preface © 2020 by Jon Stryker
Introduction © 2020 by Tim Johnston
Foreword © 2020 by Juan Battle

Requests for permission to reproduce selections from this book should be made through our website:
https://thenewpress.com/contact.

Published in the United States by The New Press, New York, 2020
Distributed by Two Rivers Distribution

ISBN 978-1-62097-580-0 (pb)
ISBN 978-1-62097-581-7 (ebook)
CIP data is available

The New Press publishes books that promote and enrich public discussion and understanding of the issues vital to our democracy and to a more equitable world. These books are made possible by the enthusiasm of our readers; the support of a committed group of donors, large and small; the collaboration of our many partners in the independent media and the not-for-profit sector; booksellers, who often hand-sell New Press books; librarians; and above all by our authors.

www.thenewpress.com

Book design and composition © 2020 by Emerson, Wajdowicz Studios (EWS)
This book was set in Helvetica Inserat, Helvetica Neue, News Gothic, FF Meta, Kenjo,
OCRB, and Zapf DIngbats

Printed in the United States of America

10 9 8 7 6 5 4 3 2 1

Preface
JON STRYKER

The project was born out of conversations that I had with Jurek Wajdowicz. He is an accomplished art photographer and frequent collaborator of mine, and I am a lover of and collector of photography. I owe a great debt to Jurek and his design partner, Lisa LaRochelle, in bringing this book series to life.

Both Jurek and I have been extremely active in social justice causes—I as an activist and philanthropist and he as a creative collaborator with some of the household names in social change. Together we set out with an ambitious goal to explore and illuminate the most intimate and personal dimensions of self still too often treated as taboo: sexual orientation and gender identity and expression. These books continue to reveal the amazing multiplicity in these core aspects of our being, played out against a vast array of distinct and varied cultures and customs from around the world.

Photography is a powerful medium for communication that can transform our understanding and awareness of the world we live in. We believe the photographs in this series will forever alter our perceptions of the arbitrary boundaries that we draw between others and ourselves and, at the same time, delight us with the broad spectrum of possibility for how we live our lives and love one another.

We are honored to have Delphine Diallo as a collaborator in *Lived Experience*. She and the other photographers in this ongoing series are more than craftspeople: they are communicators, translators, and facilitators of the kind of exchange that we hope will eventually allow all the world's people to live in greater harmony. ∎

Jon Stryker, philanthropist, architect, and photography devotee, is the founder and board president of the Arcus Foundation, a global foundation promoting respect for diversity among peoples and in nature.

Introduction
TIM JOHNSTON

I come to the topic of aging as an LGBTQ person not through my direct experience, but through working at SAGE, the nation's oldest and largest organization dedicated to improving the lives of LGBTQ older people. At SAGE, our work is guided by the statement, "Nothing about us without us." As a younger person working as an advocate alongside LGBTQ older people and our allies, I am thrilled to read this book.

SAGE has been around for over forty years, and many of our staff and constituents have lived through the traumas echoing across these stories—traumas like being rejected by family members, living on the streets, losing jobs, and facing abuse, discrimination, and institutionalization, as well as the HIV/AIDS epidemic. Many in this book speak of fear and violence—at the hands of both bigoted individuals and discrimination sanctioned by medical professionals, religious leaders, and our government. They speak of being a queer person in a world organized against us, and how surviving in that world requires fostering resilience and building community.

It is important for everyone to know and remember this history. But this book and these stories are multifaceted. There is joy and laughter in these pages; there are family members who welcome their LGBTQ children with open arms, friends who lean on one another, moments of realization when feelings suddenly make sense, and reflections on how love, intimacy, and sex change over a lifetime. Much of the struggle for our community has been to create spaces where we are affirmed, where we are supported, where we can live in the conditions necessary to flourish. Some of us were lucky to have those spaces from an early age, and many of us have worked hard to find or create them, or, as Andrew Chapin puts it in this book, "Finding my family was an adventure. It is a group of people I discovered in my life, not the people I was born into."

When it comes to finding and creating families of choice, I am struck by the number of people in this book who link their coming out to becoming politically active. These stories show us that sexual orientation and gender identity cannot be separated from the other things that make us who we are, and from other struggles for justice. To use a term coined by black feminist and legal scholar Kimberlé Crenshaw, fighting for justice must be intersectional. That is to say, we need to see being LGBTQ as just one factor that intersects with race, ethnicity, ability, class, religion, and everything else that situates our lives socially, politically, and materially. This intersectional approach is at work when Ken Kidd says, "People need to come out, and not just about their sexuality.

If they feel a certain way about immigration, if they feel a certain way about women's health, about human rights, about healthcare, about gun violence, come out!"

Does an intersectional lens take away from focusing on the specific and urgent concerns of LGBTQ people? Can it lead to an activist culture, with people pulled too many directions? That is a valid concern, and when Leslie Cagan was asked, "Don't you feel like you're jumping around from issue to issue?" she replied, "In some ways I could see how people might think that. But what I answered was that no, it's actually all the same. It's all part of the same struggle. It's not a single-issue fight, it's not about this community is more important than that community or this struggle has to take precedence over another. . . . It's kind of simplistic to say none of us is free until all of us are free, but it's actually true." Just as aspects of who we are intersect to situate our lives, so too the forces that impact one group intersect with other groups as well.

Working at these intersections is not easy, and some in this book share their struggles integrating being LGBTQ with other aspects of their lived experience. Alexis De Veaux discussed working toward coming to a "wedded sense of myself, that I was both black and lesbian, and there wasn't a way

to separate one of those realities from the other" and reflected on how when she moved to London she became engaged in community with British people of color and workers in fights for economic justice. And the fight can also be fun. Jay W. Walker is not alone when he says, "Activism brings me the greatest joy. It empowers you, it gives you a feeling of wider connection and of sort of communal, collective power, as well as the ability to know your own personal power, to be able to use your own voice and to be able to address issues that you have with whatever is going on in the world."

Several people offer advice to younger generations. Some lament that the youth do not know their own history, while others, like Gwendolen Hardwick, take ownership for this fact, stating, "You know what? If they don't know, it's because we haven't told them. That there is our responsibility. . . . If you think there's something they don't know, then mentor them." Reflecting on the idea that age should somehow impart wisdom on older people, Lujira Cooper wryly notes that "as an older person you're supposed to have wisdom. However, having wisdom is being wise enough to know that you don't know something."

The ignorant young person and the wise elder are both stereotypes. Older people have, however, lived through more of our history, and

a running theme in this book is the worry that the successes of the LGBTQ movement have made our politics less radical. Michael Bennett notes that "for us, it's all about seeing sexuality as tied up together with race and class and gender and a whole host of things. We're not so interested in mainstreaming gay folks as we are in queering the mainstream," and Cindy Rizzo asks younger people to "keep pushing at the margins, keep being edgy." Reading this book, I found myself asking, what are the radical intersectional struggles being picked up by younger LGBTQ people today? Our struggles are not defined by marriage equality, so how are we continuing to queer the mainstream? It is clear that LGBTQ people are still engaged in essential intersectional struggles every day. For example, I see a clear lineage from the folks in this book to the fact that Black Lives Matter has had a queer politics and leadership from the beginning. I see it as activists link concerns around access to gender-affirming health care to questions of disability rights and access, class, and economic justice. Or how climate change, climate justice, and immigration reform require centering the voices of those most impacted, many of whom are from the countries least responsible for global warming and are often women and/or LGBTQ.

LGBTQ people have secured many rights. We are nowhere near where we need to be, and the voices in this book remind us to see the connections, both political and personal, that can sustain us and create a more just society.

Reflecting on our current moment, Katherine Acey says, "My heart's been broken, by lovers, friends, by the injustice I see and hear, from the children in cages to walking by all these homeless people. Those are heartbreaking to me. I don't like pain, but I'm grateful I can feel pain, because it tells me I'm alive and that I am a real human being and care." Recognizing and accepting pain makes us vulnerable, and Alexis De Veaux says that "if you really want to be about love, then you have to also be about being deeply vulnerable."

Let's continue to be human, to be vulnerable, and to be in community with one another. I'll end with the words of Blanche Wiesen Cook, who I think sums it up beautifully when reflecting on her work with students: "Unpack your heart and be bold. And then, with our friends, as we go from activism to activism, I say, we are shoulder-to-shoulder, hearts open, fists high." ∎

—Tim Johnston, Senior Director of National Projects/SAGE

Foreword

JUAN BATTLE

This book has taken generations to produce. While the interviews, photos, and layout may have taken only a few years, the wisdom, insights, and reflections contained in these pages are the product of lives and experiences well beyond what you might expect. The average age of the contributors to this volume is about sixty, yet many refer to older friends, parents, grandparents—our literal and figurative ancestors—and what they have passed down to us. Both directly and indirectly, we take a portion of what was given to us and pass it through us to the readers willing to receive it from us.

The people represented in this volume successfully received that wisdom from their elders, and here, they attempt to pass it on to us. Life now is qualitatively different than it was when this generation came into being. For example, the generations covered in this volume include those who were born before DNA fingerprinting, desktop computers, Etch A Sketch, zip codes, smoke detectors, handheld calculators, and microwave ovens. When the average person in this volume was born, around 1960, the Cold War between the United States and the Soviet Union was heating up, and Kennedy barely beat Nixon by less than 115,000 votes out of over 68 million cast in the presidential election. It was also the first election in which all fifty states participated,

and the last in which Washington, DC, did not. The United States sent the first troops to Vietnam. Thurgood Marshall argued and won a case before the Supreme Court, making racial segregation in public transportation unconstitutional—a major step in a career that would eventually lead to Marshall's becoming the first black Supreme Court Justice. Cassius Clay emerged into the limelight, there were only three television channels, the top movies were *Psycho* and *The Magnificent Seven*, and the classic American novel *To Kill a Mockingbird* by Harper Lee had just been published. And, of course, the 1960s would become almost synonymous with the sexual revolution.

If the average person in this volume was born around 1960, what was happening in their world as they came of age, graduated high school, and entered adulthood? This cohort practically invented road trips, fitness running, backpacking in exotic locales, ecotourism, and adrenaline sports. They came of age while experiencing the invention of home VCRs, floppy disks, email, barcodes, Hacky Sack, pong, Post-it Notes, ink-jet printers, and MTV. And few things would have as lasting a cultural impact as Microsoft Windows and cell phones. During this same time, Jim Jones and the People's Temple, as well as the Son of Sam, shocked the American public. The Susan B. Anthony dollar was

minted, Japanese car imports soared, and the world learned of the impact of aerosol sprays on the ozone layer. The French New Wave of films washed onto these shores, and feminism's second wave began to crest. *Grease*, *Saturday Night Fever*, and *Close Encounters of the Third Kind* were the top movies, while *Happy Days* and *Little House on the Prairie* were the most popular TV shows. I have to admit, I preferred Whitney Houston, Stevie Wonder, *The Color Purple*, *Purple Rain*, *The Cosby Show*, and reruns of *Good Times* and *The Jeffersons*. We learned of microwavable bags of popcorn, ctrl-alt-del, and the space shuttle, as well as one of my favorites, being that I'm over six feet tall—tilt-and-roll luggage. Politically, the 1980s saw the rise of the New Right, with the election of Ronald Reagan, but by the early 1990s, Nelson Mandela had been released from prison, the Berlin Wall had fallen, and the Clinton era had begun.

During the 1960s, seismic transformations were occurring around how the United States was dealing with sexual orientation. For example, in 1960, sodomy was illegal in all fifty states. In 1964, one of the first gay rights demonstrations in the United States occurred when a small group picketed the Whitehall Street Induction Center in New York City.

In 1966, one of the first gay pride parades occurred in Los Angeles, and in 1967, the first-ever nationally televised broadcast on the subject of homosexuality aired. In 1969, the Stonewall riots (but what I call rebellion) occurred in New York City, marking for some the beginning of the modern gay rights movement.

As the 1970s rolled in, so too did more voices of sexual minorities, demanding and fighting for representation and rights. For example, as a result of much resistance and activism, the American Psychiatric Association removed homosexuality from its list of psychiatric disorders in 1973. Further, homosexual decriminalization laws and ordinances were passed by several cities and states. During this same era, for the first time, a few openly lesbian and gay people were elected to political offices in the United States.

Of course, this progress was not free of opposition. Anita Bryant became the face of public backlash when she led a successful campaign in 1977 to repeal a gay-rights ordinance in Dade County, Florida. The LGBT community encountered legal discrimination and outright violence, which was often overlooked or not severely punished, as when Dan White literally got away with murder, serving only seven years for "voluntary manslaughter" after

the assassination of gay San Francisco supervisor Harvey Milk and Mayor George Moscone.

On June 5, 1981, the Centers for Disease Control published the first official report of men infected with what would be known later as the AIDS (Acquired Immunodeficiency Syndrome) virus. For much of the next decade (and longer), this disease, the personal experiences of it, as well as political reactions to it, colored much of life for our communities. Activists and organizations banded together to speed up the process of advancing medical technologies as well as providing services to those infected and affected.

The 1990s and into the 2000s heralded far too many gains to enumerate. However, among them were the lesbian avengers, third-wave feminism, the designation of LGBT, sexual minorities' being allowed to openly serve in the military, and same-sex couples' being allowed to legally marry. And most interesting, while the 1970s began with homosexuality's being viewed as a mental disorder, by the 2000s, some were calling for homophobia, racism, and sexism to be viewed as intolerant personality disorders.

With these institutional advances, individual experiences, and their intersections in mind, we offer this volume. We invite you to join the conversation as the contributors—through their words and their portraits—share their thoughts about their identity, their joys, their life, their loves, and their laughter. In particular, we welcome you to ponder the advice they offer to younger generations. While wisdom cannot be bought or loaned, it can, fortunately, be shared and given.

In fact, the lived experiences of these participants—from multiple generations, genders, sexual orientations, racial and ethnic groups, as well as classes and professional backgrounds—provide unique voices in the choir of the human experience. This volume is not meant to be a representative sample, but rather a small and yet important reflection of a particular group of people at a particular moment in history. Our stories include what we have lived, learned, and, for some, what we would like to leave behind. Thus, as we have told a part of our story in this volume, we invite you to tell yours through your networks. For I am convinced that through learning about and embracing how our lives are different, we move forward in appreciating how much our histories, destinies, and legacies are alike. ∎

—Juan Battle, PhD, Presidential Professor/Graduate Center, CUNY

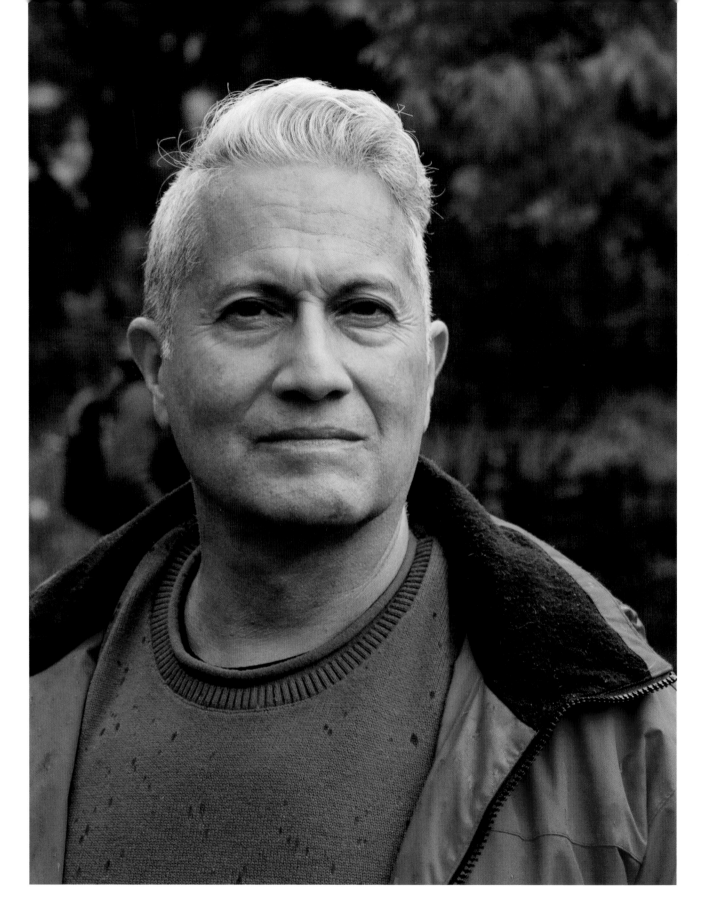

Pablo Colón

I grew up in Puerto Rico, and I came to New York City in 1986. I practice public health, and I got here when the AIDS epidemic was raging. I felt a duty to be of help. I had a good friend who was working in the field, and he told me he was working in the Bronx and he was seeing the devastation of families, Puerto Rican families in particular, Latino families. There was no information at that point in Spanish. He was working with an organization called The AIDS Data Network, and he asked for my help, and I started doing translations, fact sheets, and then we started doing treatment forums in Spanish. We got a doctor, Gabriel Torres, who's also Puerto Rican—he was the director of an AIDS treatment center at St. Vincent's Hospital—and we went to different boroughs. There were about ten of us, different AIDS organizations. We were the first ones to respond in the Latino community.

In 1989, I started volunteering at Gay Men's Health Crisis (GMHC). In the early 1990s there weren't any effective medications, really. There was AZT and then a few monotherapies up until 1996, when the protease inhibitors came, and that changed the whole treatment spectrum. In 1994, I became the clinical trials coordinator at St. Vincent's Hospital. I did outreach in the community and recruited people for clinical trials to try new drugs and therapies, including the protease inhibitors. We saw people coming back—the Lazarus Syndrome, they called it.

I got involved first of all for selfish reasons. I wanted a cure. But I was also seeing people die, people my same age, or even younger. I was in my twenties. You had an intimate relationship with death at a time when you're supposed to be not worried about that. But it was also an incredible time to see the unity of our community. My heroes are my colleagues in TAG and ACT UP.

I continued to be involved in treatment activism, and later I became the director of the Treatment Education and Advocacy Department at Gay Men's Health Crisis. I was there from 1997 to 2000. I traveled, going to conferences, giving speeches, and attending meetings with pharmaceutical companies, and taking part in coalition building and helping the cost of medications go down, helping with access to drugs that were in clinical trials. My forte was distilling very complex medical information in a way that common folk would understand. I was speaking to professionals—doctors, nurses, investigators—and taking that information back to the community, and vice versa.

We have this culture that tells us that we're doing something wrong when we are expressing ourselves by being gay, transgender, lesbian, questioning, whatever. I was taught it was wrong. I grew up in a very strict Catholic family, so that had no place whatsoever in our life. Hellfire and damnation were what awaited me if I didn't correct my ways. I asked God to fix me, and he didn't, and I hated myself. One of my biggest hurdles has been self-love. It took me until my fifties to truly confront the fact that I didn't love myself. I was finally able to acknowledge it and to really do something about it.

The most powerful thing is to transform the pain from the past into a tool to help others. Only a person who's gone through this can help another person who's going through it, and say, "Hey, I made it, you can too." It's not about preaching; it's about relating. It's like RuPaul says, "If you don't love yourself, how the hell you gonna love somebody else? Can I get an amen?"

AS

Sokari Ekine

Alexis De Veaux

Alexis (right): When I grew up in Harlem, there was no sense of an LGBTQIA community in any out way, in any public way. There were individuals in the community, like Ms. Ruthie, who lived in our neighborhood by the time we moved to the South Bronx. Ms. Ruthie was known in the community as a bull dyke, and my mother was very clear: "Don't let me catch you in Ms. Ruthie's house." But Ms. Ruthie's house was the place that I went to because Ms. Ruthie was very exciting to me. She just let us come and hang out at her house. She also had the most beautiful women—*the most beautiful women*—and she was known for carrying switchblades so she was kind of dangerous. But to us teenagers it was just a place that we could be unmolested, and just be, and watch. That was the place I learned to observe the people I seemed to have an attraction for.

I understood that I had same-sex desire from when I was a kid, but I understood that as something that was taboo. The 1950s, the 1960s, up until the 1970s, really, I did not have a sense that who I was and what I was feeling were legitimate in terms of blackness. It wasn't until I was in my mid-twenties that I began to make my

continued >

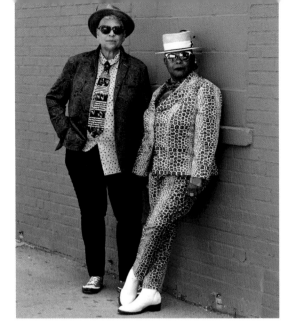

> > >

way toward an understanding of my sexuality, that I was in line with it as opposed to in friction with it, like am I black or am I homosexual? By the time I was in my thirties, I came to a more wedded sense of myself, that I was both black and lesbian, and there wasn't a way to separate one of those realities from the other. By then, it was the 1980s and I was living in Brooklyn with a partner. At the time, black women and women of color were coming out publicly and identifying as a legitimate body of people with legitimate concerns that were racialized, sexualized, gendered, and also had to do with material realities. It was the 1980s in Brooklyn that provided the larger community for me to situate myself in. At the same time, there had been a number of social movements—civil rights, black power, the black arts movement, the white feminist movement, the black women's liberation movement, and the lesbian and gay liberation movement. It helped me to develop myself as a queer person.

I understand if someone thinks of me as a lesbian, I don't have a problem with that, but I prefer to identify as queer because I think the term *lesbian* is a bit limiting in terms of how I see myself. It's not who I'm partnered with, but how I see myself.

Sokari (left): My father is Nigerian. My mother is English. I was born in London. My mother and I went to join my father, who had been studying in Britain, in Lagos. I was four at the time. That's where I spent my childhood and my teenage years. I remember always having same-sex desire, but I had no concept of what that meant. I had never heard the word *lesbian*. There were just no

reference points in Nigeria at that time, which is not how it is now. So, yes, I got married. I married a man, which was a complete disaster. It was kind of a rebellion against my parents. I grew up in a very bougie family, and I just wanted to get out of the house.

I had three children, three sons, and in late 1983, 1984, I moved to London with the children. It was this wonderful revolutionary place. I was involved with black sisters, black parents, black workers. It was during the Thatcher period so there was a lot of activism around Thatcher and around workers, but also in terms of black people and people of color in Britain, especially in London, pushing back against racism. It was a very vibrant period of time, and so I was able to just absorb everything that was happening and become involved in all these different aspects of myself, as a mother, as a worker, and as a feminist, a black feminist. Being in London at that period of time was my coming out in multiple ways, as a queer person and as a person away from the oppressive environment that I had been in. I also think it was liberating for my kids.

Alexis: We were introduced by a mutual friend online. I don't think the friend introduced us because she thought we would get together. I think she introduced us because I had a book that had just come out and Sokari was writing for a number of publications. She wanted Sokari to interview me. That never happened, and we didn't physically meet. Then, a year and a half later, Sokari contacted me by email: "Remember me? I'm going to be in New York City. Can we get together?"

And I was like, "Whatever." But we did meet.

Sokari: I was living between Florida and Haiti at the time. I was spending a lot of time working. I had received a fellowship to write about grassroots health care in Haiti. Between 2013 and 2016, I was based in Port-au-Prince and had the opportunity to travel within the country. That's when I began the journey into photography. I was in Florida to stay with a friend. I hadn't been to New York for a couple of years, because I was just too busy with this Haiti project, so I wrote to Alexis. I was actually quite surprised that she answered.

Alexis: That was how we actually began. One of the things that life has taught me is that love is not primarily romantic the way it's portrayed in popular culture. Popular culture doesn't really tell us how much work it is to be with someone else. Desire, lust, all those things, are helpful, and they work when the chemistry is there. I have learned that the more you have love, the harder it is to know what it is. And the older you get, the more vulnerable you are in terms of being open to someone else. In other words, if you really want to be about love, then you have to also be about being deeply vulnerable.

To people coming up behind me, I would say that it's important for them to live their best life and to know that there's nothing they can't do. There's nothing. Do anything you want to do, and do it with a knowledge of history, of whose shoulders you're standing on, how you got there. There were generations of people who were in the closet, or living double lives, triple lives, and unable to be who they were, so we can be who we are. ▪

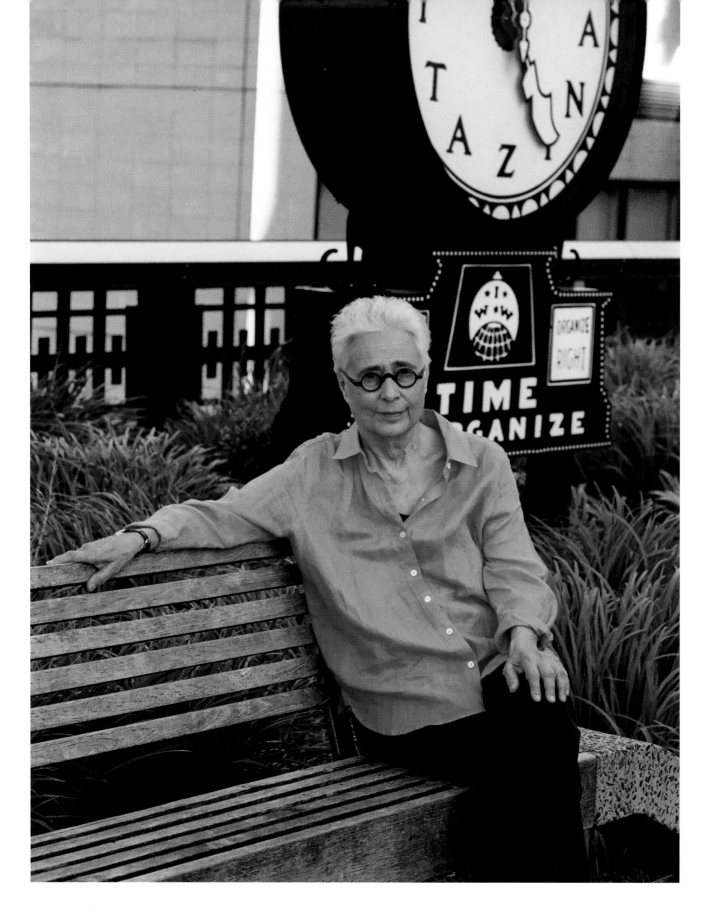

K
Katherine Bradford

I have a partner, Jane, whom I've been with for twenty-nine years, and I would say that when I look at her I'm quite certain that I love her. Especially when I look at her, because she's so authentic, and she has a wonderful way of not looking too male or too female, which is intriguing. I think I'm a visual person. When I look at her, it's love. I call her my spouse; we don't call each other wife; I just am so surprised when I hear younger lesbians refer to their wife, I think, "That is not a great word to use for anyone." But times have changed, and I think they're very proud of having a wife.

I have had a dream that I've yearned for for a long time. I'm now seventy-seven years old, and some parts of that dream are coming true. I wanted to be an artist living in New York, which I am. And I wanted to be a player. And by that I mean someone who makes art that people care about. And I feel I'm part of a community and I'm called upon to participate, and I also have the initiative to make community. And introduce people. I belong to a gallery, a wonderful gallery. It's almost like a family.

I was in my thirties when I really admitted to myself that this was what I wanted. The idea of being an artist came after I had a family, which was maybe my first dream. I was married, to a man, and I had two children. I was living in Maine, and so I had to change a lot of things about my life, to be here now. It was a slow change. I realized what an artist was, I met artists, and I saw that this was something I could do. I was getting a divorce, and I realized that I could take my two children, who were school aged, and move to New York. I moved to New York in the 1980s, and for ten years I was what they call a struggling artist. So I know that life.

I don't have one of those coming out stories that you hear about. I was happy to get married and I loved my husband and I'm glad we got married and we had those two kids. I don't reject that part of my life at all. And I think when I moved to New York those struggling years in the 1980s, I went out with plenty of guys. Then, when I met a woman who I felt was really pretty extraordinary, I realized that *she* would make a wonderful partner.

You ask what I might want to say to younger generations; I think I would say first of all, "Remember to thank people." I would say write five thank-you notes a day. They can be emails, tweets, letters, phone calls, but thank five people a day, and also say to five people what you appreciate about them. Just sit at your computer and you can do it, on Facebook or Instagram. That is the way to build a community. Do not complain, ever. I don't care if you have a horrible studio or you're depressed or your dog died, we don't want to hear it. Just concentrate on what is working for you. And if someone gives you an opening and says, "I really liked your last painting," look them in the eye and say "Thank you very much," and ask them, "What are you working on now?" Do not talk about yourself. Get the other person to talk, and this is especially true in your relationships with the professionals in the field. They don't want to hear about you or your work. Talk to them about the show they just put on, or the artist they represent, or what they wrote, or the review you admired. Talk about them and eventually they may talk to you. ■

Mark Fowler

For me, gay is not just about sexual orientation. It's not just limited to who I'm attracted to, or who I fall in love with. It also has to do with my politics. It has to do with the integration, or the intersectionality, of all of my identifiers. It has to do with certain ideas of what I believe to be justice issues for men and women, regardless of who they're attracted to, or how they identify. So in my mind, gay has moved over the course of my life from originally just being an identifier of who I was attracted to, to more of a description of my politics, my overall identity, my commitment to justice for myself and for other people.

I was not always community-minded when it came to the LGBT community. I was not someone who tied myself to the front of a pharmaceutical company because it would not provide medications for HIV. ACT UP scared the hell out of me—and I was not out. I only have humility and a little bit of shame. If those people had not taken those stances, we would not be here today. We would not have some of the advances that we did, had it not been for those people that lay their bodies down in front of public institutions saying that this crisis needed to be addressed.

As I've gotten older, as I'm now out, I feel more of the responsibility, not just for myself, but for those around me, and those that will come after me. I think I'm more aware of the responsibilities that I can take on, and in most instances I choose to take them on now in a way that I didn't when I was younger because I was afraid for myself and protecting myself.

One of the great joys in my life right now is being a minister. I'm a dean at the seminary that I attended. I love shepherding new ministers. I love that I'm able to also work with spiritual communities, sometimes providing training for people who are not necessarily clergy but who are making themselves available to spiritual service.

More than anything, the blessing of my life has been my friends I have made along the way who have strengthened me to really be my full authentic self, and provided protection for my heart. I'm just so blessed to be around people who love and care about me, and I love and care about them.

I'm discovering that I am worthy of love, and discovering the capacity that I have to love others. I'm fifty-five years old, I'm single, and I still believe in love. I'm not as afraid of love as I used to be. I've been hurt by love—it wouldn't be love if you couldn't get hurt by it—but I still believe that love is possible for me, and that I can love another person.

Overall I would say I live a joyful life. It's a joy to just live with the level of freedom and access that I have, and I really try not to take it for granted. One thing that I would say to young people today is recognize what power and privilege you have, whatever it is, and really be conscious about using it. I would also encourage everyone in a place that you are not comfortable in your own skin to find somebody to talk to. One of the big lessons that I learned in going to seminary and then doing other work is that your greatest gifts are usually rooted in your deepest wounds, and we often don't want to show our wounds. The degree to which I can acknowledge all of myself, all of my fears, all of my concerns, all of my joys, all of my love, that's when I'm my most powerful. ▪

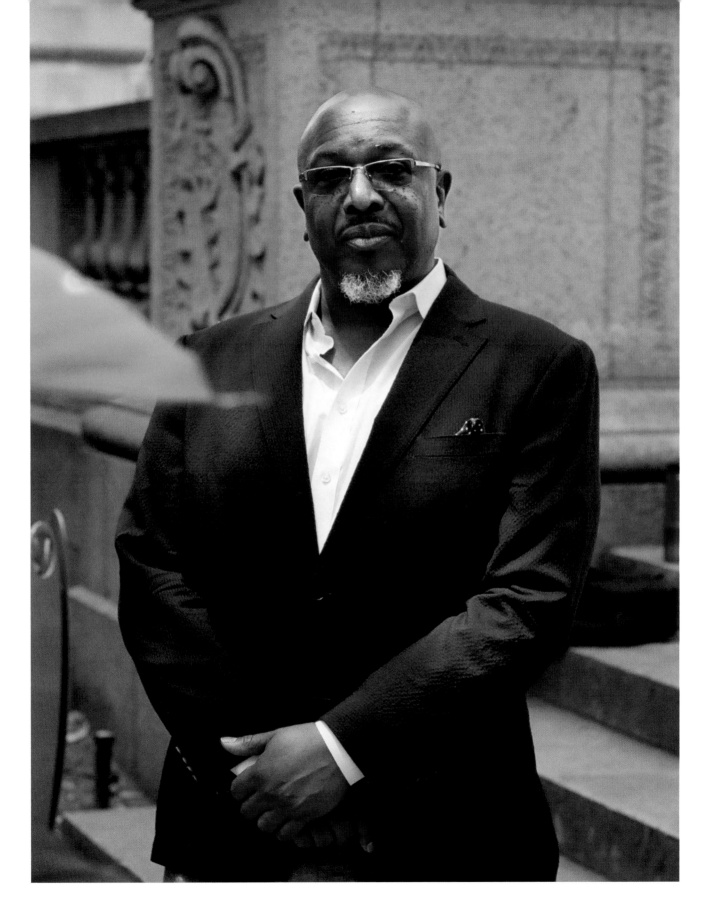

Rabbi Sharon Kleinbaum

I grew up in 1960s suburban New Jersey. We lived in a town that was primarily an Italian working-class Catholic town, a very white town, and we were one of very few Jewish families. My father was the son of immigrants, and our Yiddish-speaking grandmother lived with us until she died when I was around eight or nine years old. There was very much an awareness of who we were as Jews not so far from the Holocaust.

My father had been a pacifist during World War II. From him I learned very early on the power of being confident and comfortable with positions that might not be popular. The town was very conservative politically, and the first thing that I did for political activism was in 1968, when I was nine or ten years old. I did political canvasing with the few other progressive Democratic families in town for the Democratic candidate for president, who was Eugene McCarthy at the time. The town was very much pro-war, pro-Nixon. Doors were slammed in my face all the time.

I started high school in 1974. I went to an orthodox yeshiva in a town nearby because the school system in my small town had fallen apart. I always had been a religious person on some level. I had always cared about issues about God and meaning and purpose and what our souls need to live. It was a little countercultural, given what the world was like in the late 1960s and early 1970s, but on the other hand, everybody was asking questions about who we were and what we were on this earth for.

I became very orthodox, but I maintained my politically progressive positions. I believe what God demands of us isn't in conflict with the progressive view of God's love and care for all of God's children. The idea that God would ask us, or expect us, to be racist, or sexist, or hate immigrants, is anathema to me. It just wasn't the God that I could imagine. I could easily see how humanity was responsible for so much evil. For me in many ways it came down to this: do you believe that every human being is created as a reflection of God? If you do, then you have to treat people in a certain way. It seemed pretty simple to me then, as a teenager, and on some level it seems pretty simple now. I'm no longer

continued >

> > >

orthodox. I consider myself a deeply religious person, still, but I don't observe Jewish law in the way that an orthodox person would, although I respect those who do.

I came to New York in 1977, to come to college. I haven't really left since, except to go to rabbinical school, because there was nothing here in New York. There're two schools in New York. One didn't accept women yet, and the reform movement wasn't accepting gay people. The only one that was accepting openly gay people was the Reconstructionist Rabbinical College in Philadelphia, which in 1984 had passed a policy of non-discrimination. So I entered in 1985, and I was shocked at how homophobic it was, even though it had changed its policy. As we know, a legal change doesn't change how people feel.

In 1985 or 1986, a small group of us who were closeted went to a conference in Los Angeles that was a secret gathering of gays and lesbians. We weren't told where this gathering was going to be—that's how

secretive it was. We were given the airport to fly to and a phone number to call when we arrived. There were thirty-five of us there, and we all had to swear to secrecy. But that had a transformative impact on me and the others who were there, to have a place where all of us could be out and be Jewish.

In my second year of rabbinical school, the dean asked me to her office, and said there was a small gay Jewish synagogue in Atlanta, Georgia: would I be willing to go just to do the high holiday services in September? I thought about it, and I said, "Alright, I'll do it." I went down to Atlanta and I was so moved by being in this community of people trying hard to make meaning out of life. This was the height of the AIDS epidemic. It was so profound and moving how they were creating community and love, and light, and joy, in the middle of these terrible circumstances, completely denigrated by the larger community. It was very moving, and I felt like I had something to teach and they had something to teach, and there was a great connection. I felt like we really understood each other.

After rabbinical school, I got a position at the Religious Action Center in Washington, DC. I was the first openly gay rabbi hired by the National Reform Movement. Then two years later, this position at CBST (Congregation Beit Simchat Torah) opened up—they had never had a rabbi before—and it was clear that this would be the perfect position for me.

When CBST was founded in 1973, it was a small group that was just about having services and being openly gay. It was impossible to be gay and Jewish at the same time. If you were gay you had to leave the Jewish community, or if you wanted to remain gay you had to stay a Jew but be closeted. You had to lie in one way or another, and that's what's so radical about this institution, the people who started it. They just said, "You know what, I don't want to have to choose one or the other." They just wanted to make a statement about being whole.

The reason that they started being interested in bringing a rabbi on was AIDS. Forty percent of the synagogue died of AIDS—80 percent of the men were HIV positive. So they needed somebody here for compassionate care. I care a lot about the music and the arts, and a year and a half after I came, I hired a music director, and now we're world famous for music. Art and music are so important for people to have easy access to God's presence. ▪

Andrew Chapin

I was born in suburban Cleveland, Ohio, in 1952, when *gay* wasn't even a word people used. I had no idea what that was growing up, but it makes me laugh to look back at myself as a kid and that I had a natural attraction to Judy Garland, Liberace, Barbra Streisand. From my first black-and-white movies on television, when I was six years old, watching Fred Astaire dancing in a romanticized Manhattan, I knew that's where I wanted to be. And it wasn't until I got here that I felt I found my people. I came out, I started living a gay life at twenty. As I got to be about thirty, AIDS happened. I worked at GMHC in its early years and used to march in gay pride, which today so many people talk about as if it's a parade. I know it as a march. We were fighting for our lives. My friends were dying by the dozens. That's what made people, especially lesbians, lead the fight for civil rights and visibility. It was very powerful to me, and I've been engaged in activism and the community since then. It's been the most important and exciting part of my life.

I'd moved to New York to become a Broadway star. I imagined it was going to happen overnight, that I would be discovered, because this was the time of Andy Warhol and the Factory and that happened to people. And while I had a few near discoveries, it never happened, and I changed careers and wound up taking an office job, something I thought I would never do. It was the best thing in the world for me. It gave me stability. My acting wound up serving me in that career as a counselor. I worked at law schools doing career counseling with law students and attorneys, and as the years went on I specialized in careers doing public service as a lawyer, working for the Human Rights Campaign, working for Lambda Legal, working for the ACLU, working for the NAACP, all kinds of different organizations. The most exciting part of my job is when a student or attorney comes back to me and says, "I got the job." It always makes my heart dance when that happens.

Community is very meaningful to me, feeling a part of a community. Also, making a difference in the world. For example, when I worked on marriage equality in New York State. I thought it would never happen. And it did, and it was thrilling. Days after we finally got it signed into law, my husband proposed to me.

I share life experiences with my husband. Our growing up was very similar, though we lived in such different places. His family was very rejecting of him the way that my family was rejecting of me, and that's bound us together. It's an absence, an absence of family that we could go to for safety and support. My family, I know they were doing the best they knew how to do; I don't think my family knew how to deal with it. I don't blame them. Not many people did in that time. It's gotten better because I have been visible and made an effort for them to be aware. They have learned and grown and been supportive. They all came to my wedding, though I know that some of their religious and community standards were in conflict. I give them stars for that. They came, they participated, and they loved me, and they wished me well.

For me, finding my family was an adventure. It is a group of people I discovered in my life, not the people I was born into. And love has been a huge surprise. I'm now sixty-six years old. I had given up that I would ever meet the love of my life, and he appeared when I was sixty, and we've had the most wonderful relationship of my life. It still gives me goosebumps. I have lots of friends and acquaintances who have been important to me along the way. It's my community that has really become important to me. My community is my family. ▬

C

Cheryl Clarke

I guess I can say I came out in 1973. I was at Rutgers as a graduate student, in English, and I attended a Gay Liberation conference at Rutgers. I wasn't out then, although I was attracted to a particular woman who wasn't all that interested in being a lesbian. I went to a workshop on race and sexuality, and there were four black women on the panel. They belonged to an organization in New York called Salsa Soul Sisters. I heard them speak. In fact, one of the women was a woman I went to college with. I saw how out they were and how knowledgeable they were about lesbianism, so I said, "Well, with all of these really great black women out there, why am I in the closet?" I felt that being a lesbian offered me the opportunity to live an unconventional life as a woman, which is what I wanted. I did not want to live a conventional woman's life. I'm an unconventional woman, and I like the company of women better. Yes, I did, I still do.

I do a lot of writing. I have five books of poetry, and a book of essays and poems, and also a book of black feminist criticism on women poets and the black arts movement. I met Barbara Smith in 1975 and got to know her over the years, and Audre Lorde, and I began to seriously consider the politics of black feminism. I got the opportunity to write for *This Bridge Called My Back.*

I went into administration at Rutgers, student affairs, in 1981, and I was the director of services for LGBT students. Rutgers has one of the oldest gay student alliances in the country. It was started in 1969, and during those days a gay student organization was for everybody—students, faculty, staff—because organizations were so scarce. It was a very open environment, which helped.

I met my partner on the job, at Rutgers. She ran the women's studies undergraduate program. We've been together since 1992. Love means many things, from the emotional, the erotic, to the practical. We love many things, not just people. I love literature, I've spent my life at it. I love music, I love listening to Billie Holiday.

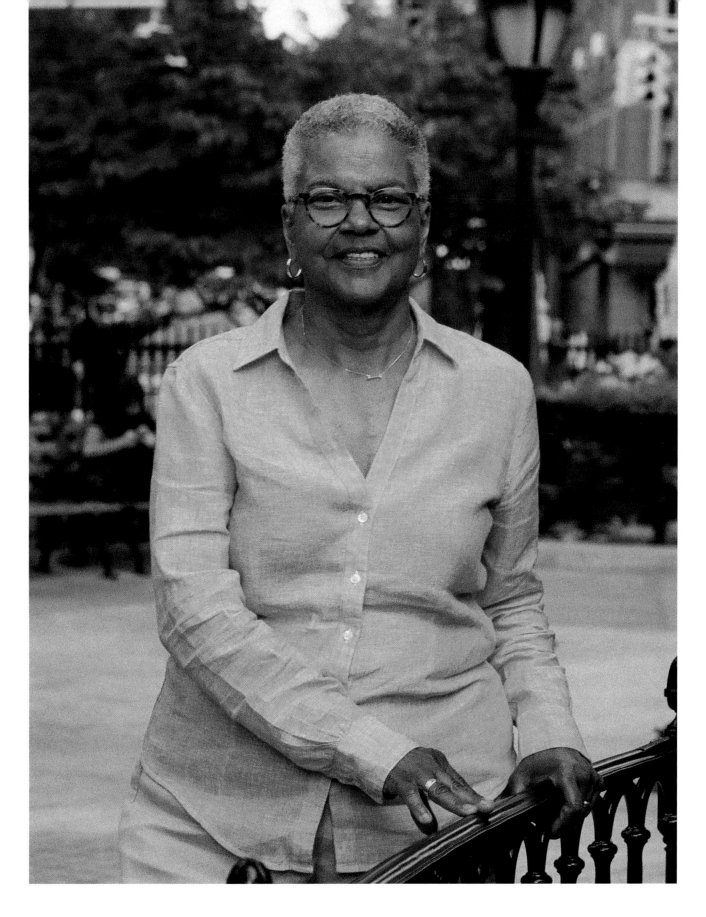

K

Ken Kidd

There's a photograph of me that was taken in my snowsuit when I was about three years old. I'm doing a full, beautiful pirouette in the snow. I was full of joy, and that's who I am. It's a great picture. And the man that I am now is constantly looking for that joy. That day is my first childhood memory. I remember being in the snow, I remember loving that plaid coat that I had on. I remember it was very safe. It was home.

I grew up in Virginia, in a Southern Baptist household. My father was a deacon in the church. My mother and father both taught Sunday school. And my older brother, even now, is a minister. There was one particular time when I was five, in Sunday school. You were supposed to draw your house and your family. I drew a house, and a car, and there was a man standing out in front of the house. And the teacher asked, "Is that your father? Is that your dad?" and I said, "No, that's my husband." The teacher, I remember her saying, "That's

a great house, but that's not right. Boys don't have husbands." And my father came down after Sunday school to take me up to church. He took that picture, and threw it away, and said to me, "I'm ashamed of you." That was the worst thing that he could have said to me. I learned to sort of tamp it down, a bit. A good bit.

My first boyfriend was my college fraternity brother at a place called Concord College, in Athens, West Virginia. While I was there, I started subscribing to the *Village Voice*, and I started reading about pride and learning about Stonewall and learning about Harvey Milk and realizing that there were not only role models but heroes that I could attach myself to, that there was an acceptance out there. We ended up leaving. Dropped out of school. We ended up going to Charleston and then DC. I was blissfully in love, until I realized that this guy was not a good guy. He was dicking around behind my back, and he got abusive with me. My best friend, Matt, whom I met in Charleston, he had my back. He

continued >

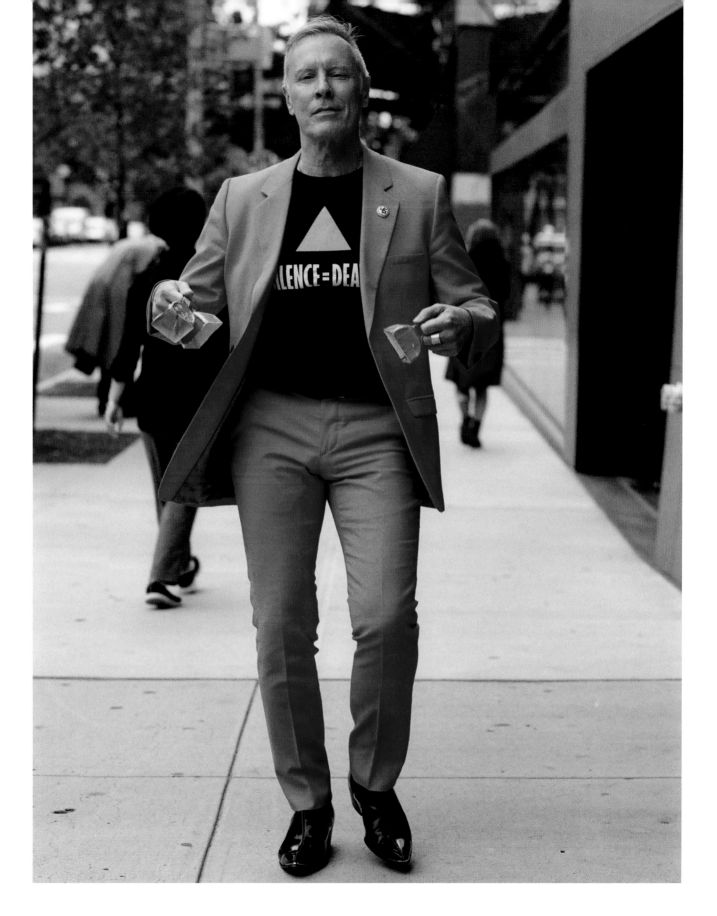

> > >

was going to NYU law school, and he offered me an out. He said, "You have skills, you can get a job at NYU, and you can finish your degree there." He got me out of there, and I started working at NYU law school in 1979.

I got to New York, and the first week that I was here I was protesting. They were making a movie called *Cruising*, which was about the gay world of S&M, which was fine, except they were telling a sensational story about gay people murdering straight people, and that was the only role on screen at the time. And so the very first week that I came to New York, I was protesting, in addition to still being a part of the very first March on Washington for LGBTQ rights in DC. I hit the ground running here, and I've kind of never stopped.

I talk about how I had to leave home in order to be safe. Very shortly after moving to New York I got gay-bashed. I got beaten up within an inch of my life by three guys who jumped me from behind and said, "You're a fucking faggot you don't deserve to live." They jumped up and down on my face, on my head, on my chest, they broke my ribs, they knocked my

teeth out. They broke my jaw in two places. I had a hematoma on my brain. I was in the hospital for two weeks. It was on Montague Street in Brooklyn Heights. It was ten o'clock at night on a gorgeous night. Streets were full. Nobody did anything.

The cops took me to the hospital, and they refused to file a police report. They blamed me for it, saying that I had tried to hit on these guys, which I had not. Then the hospital didn't believe me. They left me sitting in the emergency room that whole night until about 6:15. I was covered with blood. When the police took me to the hospital, they said, "Who can we call?" and I gave them my best friend Matt's number. And he came to me in the hospital. I'm sitting there, and Matt says to the security, "We need the key so I can take him in and clean him up." And the security guard says, "I ain't letting two faggots go in that bathroom together."

I was twenty-one. When that happens to you, and you realize that nobody else is going to do anything about it, that's what causes you to go into action. Right about that same time was the AIDS epidemic.

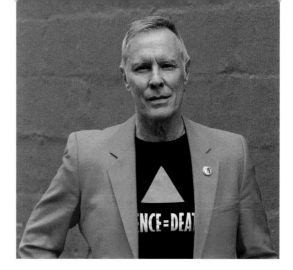

My friends started getting sick and dying. And nobody was doing anything, and they made it clear they weren't going to do anything. ACT UP was formed because we knew nobody was going to help us if we didn't do it ourselves.

I have to say what brings the greatest joy for me is being with my comrades out resisting and celebrating the advances that we've made but also encouraging people to become a part of it. One of my heroes is Harvey Milk—I knew of him before he was killed. There are wonderful videos of him and audio of him telling people to come out. You should come out to your shopkeeper, let them know that you're LGBTQ. You should come out to your family, it will give them a touchstone and make it real and make it not scary. He said when you do, you will feel so much better. People need to come out, and not just about their sexuality. If they feel a certain way about immigration, if they feel a certain way about women's health, about human rights, about healthcare, about gun violence, come out! Especially if you're my age, you've got nothing to lose. If people don't like you now, if you're worried about what people think about you now, you need to seriously get a grip on your reality. That hourglass is turned over, honey. And if you are younger than me, you have a future ahead of you, and you shouldn't care anyway. I was caught up way too long in what people thought about me. I'm here to tell you that it didn't do me any good. It didn't do me a whit of good. Because what did I try to do? I tried to alter who I was. And guess what? That didn't work out. Don't do that. Be yourself. ▬

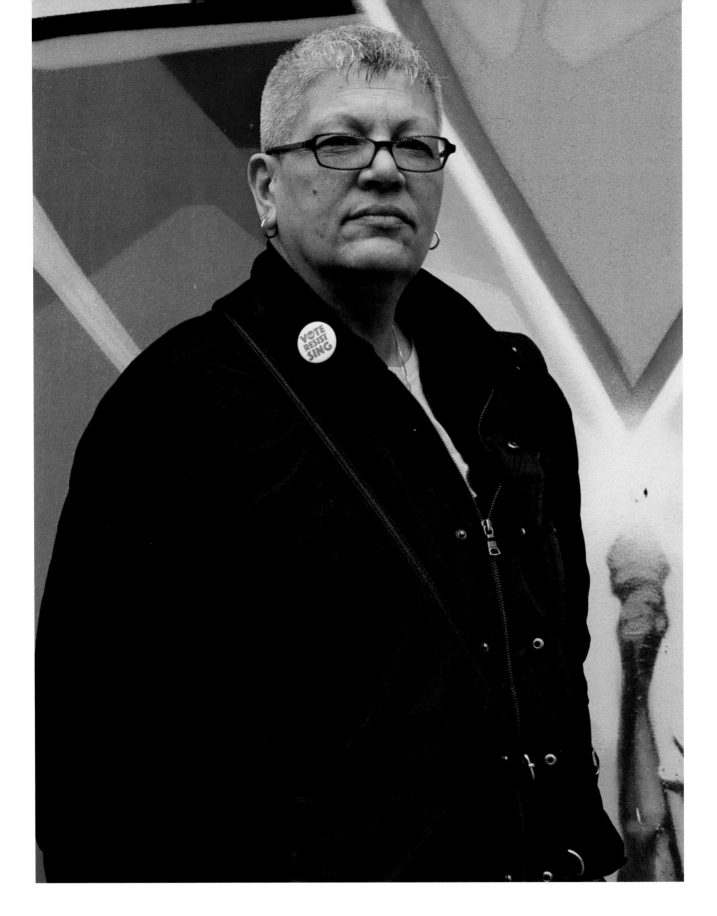

C

Cathy Marino-Thomas

I came out right after high school. I was finally happy to have the answer to why I wasn't really thrilled with the dating scene. I had one boyfriend through high school. He was a very nice man, but he didn't inspire any creativity. So once I started thinking about my sexuality and I realized that there were other options, it all clicked.

I know for sure that I'll be married to Sheila Marino-Thomas for the rest of my life. We've been together for twenty-five years, and we have a nineteen-year-old daughter. We have had the family battles, and we have pushed up against the norm of our heritages. Both of us come from backgrounds that have a very clear expectation for their daughters. I stood up against my dad in coming out, and once you do that you can be out anywhere. I know that my wife loves me, and I know that I can count on her. We've had many ups and downs in life, but not between us. There's been a lot of outside things that have happened to our family, but our relationship has only gotten stronger. So as far as love and romance goes, I got it all, baby.

My very first step into activism was as an AIDS buddy with the Gay Men's Health Crisis. It was the first, but not the last, time that I got that burning sensation in my gut that I had to get up and do something. Our community was hit with HIV and AIDS, and I saw how blatantly our government was ignoring our community and allowing us to die. I went into GMHC and volunteered to be a buddy. To this day, it's the hardest job I've ever had, but it taught me that I have power. That I can get up and get involved in something and make a difference.

The second time was marriage equality. I was the board president of Marriage Equality USA for about seventeen years. I've spoken around the country on the right to marry, what marriage gives you that no other right gives you, and why families need the right to marry, whether they choose to marry or not.

I thought I was going to take a break in 2015 when the *Obergefell* case was passed in the affirmative, but that didn't happen, because on June 12, 2016, a gunman walked into the Pulse nightclub in Orlando and killed forty-nine of my brothers and sisters, and injured many, many more. I was inspired again to get up and do something, and we're currently working against bad gun laws. My wife knew the second it happened that it would mean a new movement for us. She could see it in my eyes, I think. We've started a new group called Gays Against Guns. We are a direct action group. No other gun violence protection group has done street action around this issue before. We're not afraid to push the envelope, get arrested, make a fracas, cause some noise, and we've done that.

I like to think I have a good sense of humor, but I laugh at our opponents, often. I find it's better for my psyche than to get really mad and upset. I laugh at their stupidity, and I laugh at their short-sightedness.

We live in a democracy. Any law could be changed. I know that, because I changed the law. If you feel inspired about something, use the system and get it changed. Our government works for us, and the system really is made for citizens to protest what they don't like. I have said to younger people, and I will continue to say, stand up for yourself and speak out and just don't be complacent and take stuff. We don't have to do that in this country. ▬

T

Tom Martin

I always knew I was gay. When I finally told my mother at about thirteen, she said, "Oh, boy, please, I've always known that." So, I was very fortunate. When I was young, thirteen, fourteen, I had many gay friends. In my lifetime, I've seen many other young gay men and women struggle with being gay and coming out, accepting who they are as a gay person in the world, with no support from the people who love them most. You know, as a kid, you look to your parents. If your parents say, "The sky is green," you're going to believe them because they take care of you and they love you, even if you know that isn't true. So when they reject the thought that you might be different, it's devastating. And there are people who lost their lives, who chose to leave the world, rather than disappoint. Although I have not had that struggle, I've experienced it many times over vicariously.

I think everybody needs to find what God intended them to do. Once you figure that out and you put the work in, your life blossoms because there's a place that's yours to nurture and to create and to take care of. Nobody else can do it but you, because it's yours.

Acting was that for me. I remember when I was a little kid, in the sixth grade, wanting to audition for a role. As a kid I lived in musicals and movies, and when I told my parents that's what I wanted to do, they said,

"That's ridiculous. That's not a real job." So I went to college and studied business management, and there was a school, the American Academy of Dramatic Arts, that was just a couple of blocks away. I went. In the lobby, I saw pictures of the alumni. Robert Redford and Barbra Streisand had gone to this school. I was looking at all these amazing actors. I left school and I went to the American Academy of Dramatic Arts. It was my choice, and I was very excited about this new journey of being an actor. I was passionate and I was hungry. And I did a few great things in my life. At this point, acting still brings me joy. I love being onstage. I love it, and it completes me, and I can act whenever I want to.

Bartending helps me pay the rent between gigs. I'm at this age so I need to get up and have some place to go. I see people at my age just shrivel and become very unhappy and ill, psychologically and spiritually. I need people. I need to talk with people. I need to be around people I like and who like me. I need a glass of wine, and I like food.

I have one son and one daughter, but I have nine grandchildren and six great-grandchildren. At Thanksgiving they put me in a big chair, and they give me babies in each arm, and I sit there, and they bring me drinks and feed me. The kids, they bring me joy. ▬

Alma Gomez

I was born in New York City. As part of the 1950s diaspora, my parents came to New York City from the mountains of Puerto Rico, looking for work and better opportunities for their children. They settled on the Lower East Side, now known as "Loisiada." Ultimately, they were forced to navigate identity, place, belonging, and discrimination. My mother worked in a factory, sewing. My father was a button maker for nineteen years. He was a union organizer for a time, and he helped make us all political.

I grew up with six brothers. Upward mobility was moving into the projects, and we moved into them when I was five years old. We were one of the first Puerto Rican families living there. The focus when growing up was on economic status. In other words, how do you do more with what you have? That was the struggle. My mother was education focused, so she put us in Catholic school. There, I discovered English and the pain and power of a second language. On the heels of Vatican II, there was a paradigm shift in the understanding of what a committed Catholic life was in the world. The nuns

continued >

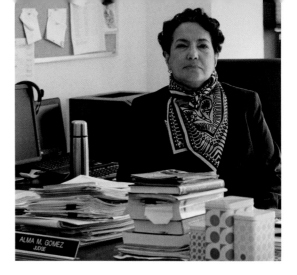

> > >

taught us to read and write, but they also taught us about compassion, justice, and cooperation. We were very lucky.

I was my father's favorite. He taught me how to box when he taught my brothers. I wasn't afraid of anybody. High school was great. I went to a Catholic all-girls high school, and I met my first lesbian there. Her mother, when my friend was sixteen years old, put her away in a psychiatric hospital for the summer because she wanted her cured of this disease.

When I was sixteen, I worked at Henry Street Settlement, and I remember meeting Angela Davis at a conference in Chicago. That was amazing. I began college at a time when this country, polarized by the Vietnam War, Third World, and women's liberation movements, seemed to be coming apart. My under-graduate and graduate school life was marked by my involvement in student government and protests. I also became involved with the Puerto Rican independence movement. That was my major awakening.

In college, I was engaged to get married, and I kept having these dreams of walking down the aisle and tripping. I thought, "This is not a good sign." I met this woman who was engaged, like me, and we were attracted to each other. The first kiss I had with her I thought the earth was moving. I got scared and left for Puerto Rico. When I came back to New York, I tried to figure myself out, and realized that I preferred women. I remember living with a group of women in an Episcopal bishop's home, in Brooklyn Heights. One woman called up my mother and told my mother that her daughter was sleeping with another woman. My mother confront-ed me, and I remember saying to her, "If you're brave enough to ask me, I'm going to be brave enough to answer your question." And I said to her, "Yes, I am." She was so upset with me, and never accepted any partner that I had. But my father and my brothers never rejected me.

After college, I became an elementary and English as a second language teacher for about two years. I thought that as a teacher, I would be of service to the communities I represent. Subsequently, I went to graduate school and became a social worker. My primary involvement was in union settings, a foster care agency in East Harlem, and a community mental health center in the South Bronx. For close to ten years, I was a clinician working with children and families, a grants writer, a program planner, a community organizer, and an administrator. I have also taken an active role in a

number of women's organizations, including Kitchen Table: Women of Color Press and the Astraea (first the Women's and then) Lesbian Foundation for Justice.

When I was thirty-five years old, I thought about either having a child or going to law school. Law school won out. Those years were difficult. My lover at the time, Maria, developed cancer, my brother, Willie, developed AIDS, and my father also developed cancer. I was the caretaker for all of them, running around to appointments, cooking, doing everything, and going to school. Maria died. My brother died, and my dad also died during that time. It was hard. But I said to myself, "I'm going to get this degree, even if I have to do it on my knees." And I did.

HIV and AIDS rapidly became leading causes of death for men and women of color in large cities across this country. I became concerned about the troubling lack of access to health care and the racial disparities of the AIDS epidemic. After finishing law school, I was awarded a Skadden Fellowship to work at the ACLU's AIDS and Lesbian and Gay Rights Projects. Race, as it intersected with poverty and sexuality, among other factors that lead to health inequities and social exclusion, became the focus of my civil rights work.

Eventually, I went to work as a law clerk for a judge, who was my law school professor. When the judge retired, he said to me, "You should think about being a judge." And I did. I applied for either a criminal or a civil court judgeship. In the middle of the interview, one member of the mayor's screening committee asked me, "Would you think about family court?" I said, "Yes. I would." It was a way of combining both legal and social work principles. About five years ago, I was named to the family court bench. The first week in family court, I remember coming home very depressed. Sometimes I would lie upon the couch, with a glass of wine, and just stare at the ceiling. It was hard at the beginning, but then, not that you get used to it, but you realize what it is you can really do, both fairly and appropriately, to resolve the legal issues that brought each family to your courtroom.

Many things give me joy—my compañera, my tribe of good friends, mi familia, small gifts of time, great food, music, and books. I especially enjoy mentoring young people. Life is short, messy, and complicated, and yet I believe that we all have a purpose in life. Mentoring is an important way to make a difference. I think it's crucial to affirm whom you are mentoring; elevate that person's voice, experiences, and skills, especially in our current political climate, and provide support for her goals and ambitions. I am certainly grateful for all the mentors who were there for me. ▭

Andrew Robinson

I was born in Camden, New Jersey. It's kind of a tough town. I was born right around Stonewall. When I was an adolescent, Harvey Milk got shot. The politics were in the air when I was growing up, but even though my family was liberal-ish, they were also deeply conservative when it came to things like that. As a kid, I already knew I was gay, but I didn't really want to come out of the closet. My congregation was deeply hostile to the idea. My town was. The whole country was. And this was even before the AIDS epidemic. I didn't really come out to my parents until my early twenties.

Sexuality and art collided early for me. I'm terribly dyslexic, and I mention that because it exposed me to some really great art educators, some of whom were gay, but of course they couldn't be out back then. I learned a lot from them. I learned about music from one person, Dick Connelly. He was the choir director at the Episcopal church I went to, and he taught us all how to sing. When I was, I guess, twelve, Dick got sick. He got what was then called GRID, or gay-related immune deficiency, "gay cancer." It was AIDS, but they didn't have a word for it then. So Dick got sick, and we all watched him get sick and die.

I remember the cantor once made a joke from the pulpit about homosexuals and the sacramental wine, and how they were making a new policy in the church about having separate glasses. To my astonishment, I watched this woman, Grace, who was Dick's best friend, a real church lady, stand up and turn around and give a lesson to the whole congregation, interrupting the sermon and giving the community the facts she knew from the CDC. She did things: she came down to St. Vincent's, she volunteered when nobody else would even go into the same room as these people, she would come in and take care of them, so I got these lessons of really brave people really early on—to be courageous and radical in your love for your fellow man.

Politics colored a lot of what I learned early on. The first time I walked into The Center, it was falling apart. It was covered with graffiti, and the bathrooms were kind of shifty. It was 1987 or 1988. I had just graduated or was about to graduate high school. It was late at night. I was seventeen, I was curious, I wanted to meet people, I wanted to pick up men. And what I met was a group of angry, activated, political, vocal, unafraid but terrified gay men and women who were really pissed. I had walked into the first main big room, and there was an ACT UP meeting, and they were planning their next action. It was a real revelation to see that. They were ready to fight.

Imagine you grow up in the 1970s and everybody's having sex and everything's wild, and everything's being challenged, and then you come into the 1980s and there's Reagan and Bush and the Moral Majority and people are praying for you to die. The *New York Times* didn't use the word *homosexual* until the 1980s. The word *AIDS* wasn't even used. They didn't even talk about it. I don't think that stuff ever went away. It's all still here, and it will not go away without a fight. One of my favorite quotes is by Audre Lorde: "Your silence will not protect you." I just love that about her. I love her gutsiness to be exactly who she was and be completely unapologetic. Why should she have to apologize? It's a refrain for me, for me to be a gay man.

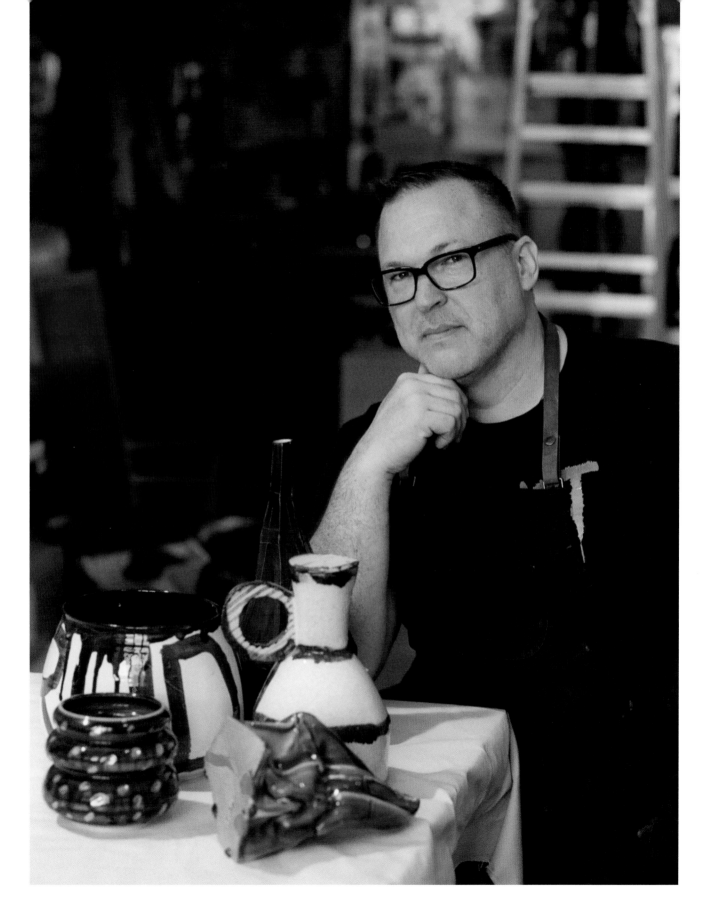

J

Judith Kasen-Windsor

I was married to Edie Windsor. She taught me so much about love, and how to love, and who to love—basically everybody. I think the greatest thing that you can do is leave this world a better place and she left this world a better place, and I think it is our responsibility to carry on that wonderful, bright, positive energy that she brought to this community. We fought for so many rights, we've gained so many rights—they're not privileges—but we have to keep at it every day. We have to respect that these things could be taken away from us.

The Defense of Marriage Act was signed in 1996. She'd already been with Thea for thirty years, and so what a blow it must have been. It took a lot of courage to stand up and help overturn DOMA, and then be as humble as she was afterward. She talked to everyone, she listened to everyone's stories, she took selfies with everybody. There are thousands and thousands of pictures of Edie with people. She loved meeting everybody. She really embraced her role. She understood who she was in this community, and it was important to her to listen to people and listen to their stories. Everybody has a story, and everybody's story is important, and it is important for us to listen.

People never forgot when they met Edie Windsor. When they met Edie Windsor, you knew it. People always say to me, "I remember the first time I met Edie." Edie carried herself with such dignity and such pride. She had nothing to be ashamed about. She just wanted to be treated as a dignified, classy, beautiful human being, and that's how she should be treated, and that's how her legacy should go down. She believed in this country, she believed in the Constitution, she believed in justice, she believed in equality, and that's what she fought for. And I always tell people: Edie didn't just land on the steps of the Supreme Court. Edie had forty, fifty years of activism behind her. She was one of the founding members of The Center, and she was one of the founding members of East End Gay Organization, which is now the LGBT Network. She had a whole career at IBM. She had a full life.

I met Edie and Thea right before Thea passed away. Edie was always around in this community. She showed up for everything. That's how we got to know each other. We were always showing up, we were always seeing each other. I had a little crush, I was just persistent, and finally she said yes to going out with me.

If anybody deserved to get married and fall in love, it was Edie Windsor. She helped overturn the Defense of Marriage Act. Sometimes I pinch myself and I wonder, how did I get to be that person? But I was that person. I can understand it now because I'm going through it now. When I go to events, I'm talking to people and I'm loving people and we're chatting and Edie always comes up. But then I go home alone. It's very similar to what Edie was doing: she was going home alone, she'd lost the love of her life. I've lost the love of my life. She never wanted to be without love, and she just loved to love, and loved people. She was all about love. ▬

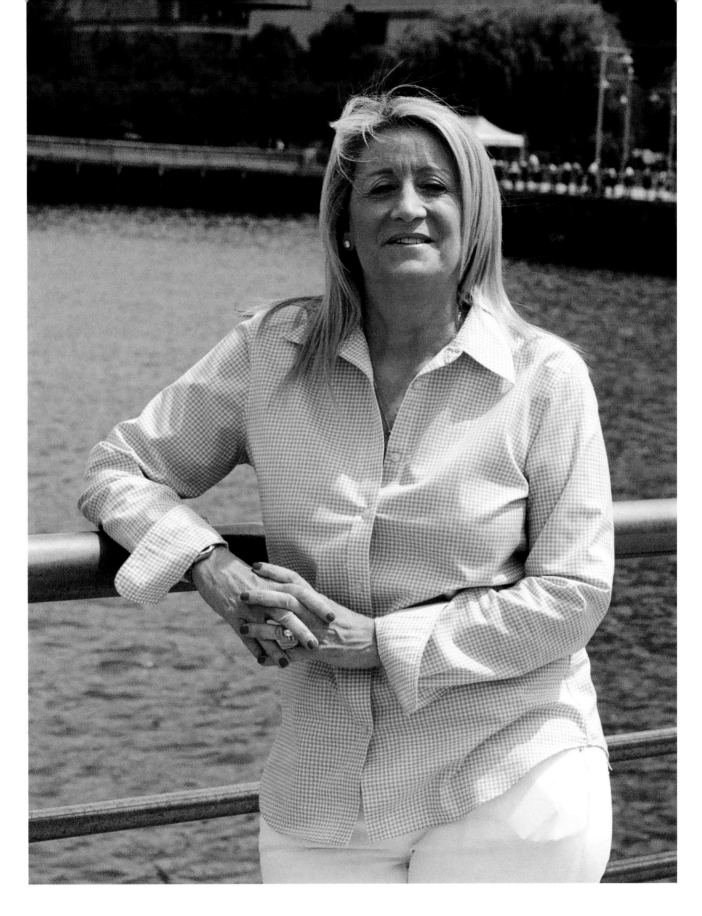

Marc Antonio Akam-Chen

I was born in Panama, in the Panama Canal Zone. My old man is from Trinidad, my mom's American from DC. I do have a large family. My old man was married four times, and he has nine kids. I'm the seventh. I think when you get to number seven, you're like, "Oh, another one?" I was kind of handled that way. He worked for the government. My mom was going to school, she wanted to be a gym teacher, but then, raising six kids, she became a homemaker. But my mom was a dancer growing up in DC. She grew up with Chita Rivera and with Louis Johnson, who did the choreography for *The Wiz*. So, I had an artistic background on my mom's side, and my father's side was more politics.

I was raised heterosexual. Then I thought I was bi-amorous because I was attracted to both genders. And then I fell in love with my best friend, who was a male, and then I decided just to go the one route. I came to the States in 1966. At sixteen, I met some friends, my best friend, and then we were hanging out, trying to do dope, go to the clubs, in DC, in Maryland. We were underage in the bars. Later I met another older couple. They were together, they were out, and I would be in DC, you know, Dupont Circle, holding hands with them. And we were very free and very loving. We're talking 1976, 1977, 1978.

After high school, my old man basically gave me an ultimatum: either pay him rent or move out. He had left my mother for another woman. So, at seventeen, I was on my own—no job, no place to live, very difficult. And then I came to New York in 1979. Stayed with a friend of mine in Hell's Kitchen, went to the Village, checked out Christopher Street. I remember meeting Marsha P.

Johnson. She was wonderful. She was the mother of the Village. And I met some other people there and then got more involved. I worked in music, TV, film. I use the media to promote human rights and advocacy.

It was really fantastic growing up in the late 1970s, early 1980s. Disco was due to be born. I happened to live on the block were John Lennon did his last album. I actually saw him and Yoko Ono get out of the limo and wave to us. I remember six months later, I was down in the Village at Sixth Avenue, near Bleecker, and I'm walking around, and I see Bob Marley. That was amazing. I was like, "Here are these two guys that I'm into," and the message was peace through music, and that's my thing as an artist. I think I've got to do something. And I've had a lot of stuff happen because I care so much. And things are very personal to me.

I worked with different film companies, and I knew I wanted to use media. So, I ended up going to California, working production. Then I ended up going from behind the camera to in front of the camera and doing some acting. I got more involved in the communities honoring actors who couldn't get jobs in TV and film. We were doing nontraditional casting. I was a founder of the national Screen Actors Guild LGBT committee—to protect us when we come out because there was nothing like that, protections. Recently, the Casting Society of America had a town hall, and I was consulting on that, and they were asking about LGBT inclusivity in TV and film, especially around transgender persons. And that led to *Pose*. Great seeing that was how *Pose* happened. ▪▪▪

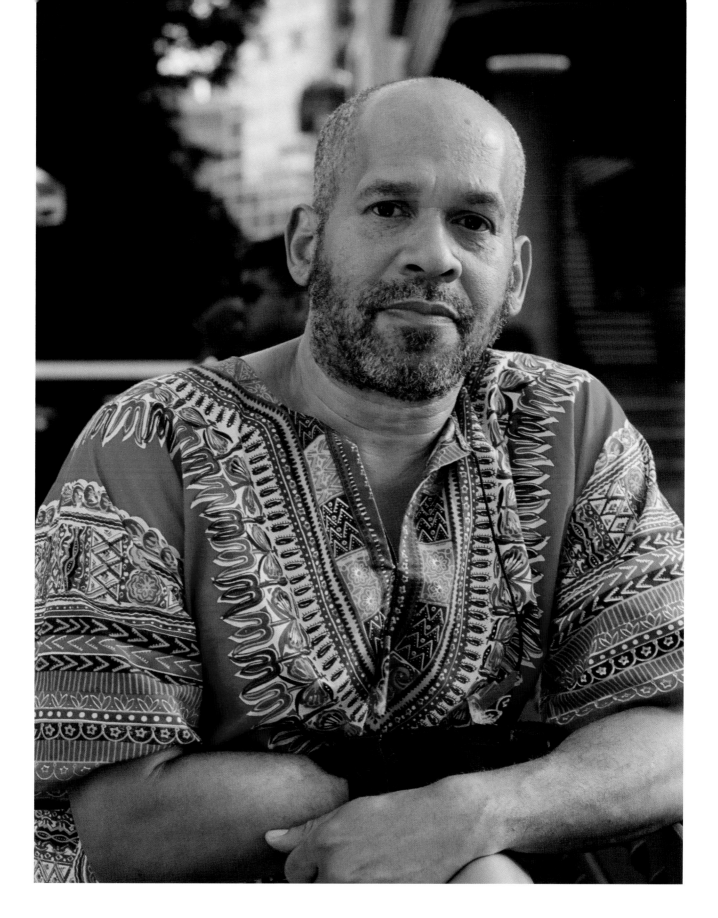

BC

Blanche Wiesen Cook
Clare Coss

Blanche *(left)*: I always say my life was an accident because I was an athlete, a gymnast, and a boy put a barbell at the end of the mat as I came out of a triple flip, and I broke all of the muscles and ligaments in my back. So then I couldn't major in phys ed, and I majored in every course I took: anthropology, history, political science. And I'm a historian and an activist. So, my life has been an accident, and the best accident was that I met Clare in 1966 at a Women's International League for Peace and Freedom meeting. It was love at first sight.

Clare *(right)*: It was love at first sight. It was in a church on the East Side. We disagree about which church it was. But it was 1966, and the meeting was to plan an action against the war in Vietnam. It was my first time at a WILPF meeting in the city. I had just come down with my husband from Buffalo. It was just an incredible circle. She was over there, and I was here.

Blanche: After the meeting she ran out down the staircase. I went around the room trying to find someone who knew her, and I found a good friend who had brought Clare to the meeting. We called a meeting to plan an action to keep the libraries open at night. The

continued >

> > >

New York Public Library was then closed at night and on weekends, and we protested, saying working people needed the library and all the working students needed the library at night and on the weekends.

Clare: Judith called and said we are having this meeting, and I walked into the meeting and there was only one person there. I couldn't believe it. She walked me home after the meeting, and that was the beginning of three years of activism and getting to know each other, and we double dated with our husbands. She was already in the life, but I was straight. She had to go slow so she wouldn't scare me off. And I had to go slow. But we didn't go too slow.

Blanche: On our fortieth anniversary we got legally married on Bill Preston's deck in Martha's Vineyard.

Clare: Because it wasn't legal yet in New York.

Blanche: We first got married in Massachusetts. But we've been legally married for ten years.

Clare: Ten years, but together fifty. We each got divorced and started to live together in 1970, or 1969. Actually, I was the one who initiated leaving our husbands and living together. I was ironing, my husband was teaching the Trinity term at Oxford, and I was over there working on a play. And I was ironing, because he liked his boxer shorts ironed. And all of a sudden, I felt like Picasso's *Woman Ironing* in his Blue Period. You know, that haggard woman with the iron. I put the iron down and I wrote to her and I said, "You know, we love each other, why are we living with them? We must leave them and live together." And she didn't answer me. And so, she arranged to come over to do research at the British Museum and took the red-eye, and Sam went to bed, and you and I walked to Russell Square in the shadow of Bloomsbury. And we sat down on a bench. And oh, she had great legs. She had this little macro skirt. And I said, "Why didn't you answer my letter?"

Blanche: "I wasn't sure you were serious."

Clare: "I am serious."

Blanche: "Well, yes then." And that was it. I had showed the letter to Audre, who was my best friend, and I said, "Look at this. Do you think she's serious?" And Audre said, "She is serious."

Clare: I grew up in New Jersey and New Orleans. I went back and forth because my mother was from New Orleans. I was very sensitized to race and Jim Crow because in the South it was Jim Crow and it was very disturbing to me. It did affect a lot of the work I have

done as an adult, from that experience. I went to a boarding school in Locust Valley, in Long Island, and then LSU in Baton Rouge, this huge land-grant college that was a Jim Crow undergraduate college. I was there when Emmett Till was murdered. I was starting my junior year. After LSU, I came up to New York and got a degree at NYU. I love New York. I couldn't wait to be back up north. I studied for my masters at NYU and met my soon to be husband. I taught theater at Hunter, and created plays with the Soul and Latin Theatre in East Harlem. Later I started a teenage street theater troupe in Calgary, where my husband taught at the university. Blanche came to visit us twice.

Blanche: I'm a New Yorker, from the Bronx. I always say "Never go anywhere without your gang." In the Bronx, I had a great gang. I would go to Hebrew school; I was the only girl in Hebrew school. And my gang would come with me, and we would beat up all the kids who would try to beat me up. So that just left me with this "never go anywhere without your gang" motto. I was on the debating team and all the various teams and went to Hunter College and then to Hopkins for my PhD. I started out a military historian and became a peace historian during the war in Vietnam, and co-created the Peace History Society.

My first teaching job was actually in 1963 at Hampton Institute, which was a historically black college, which was very informative and important to me because I really didn't know how incredibly insanely segregated the world was until I experienced it. I got a job at John Jay, as early as 1968. And my best friend at the time, we met at Hunter in 1958, was Audre Lorde. She was my first lover, and her children are our godchildren. I met her in 1958, and she was our best friend until she died.

Clare: It's hard to believe that we have been so lucky. We had a very dear friend, Annette Rubinstein, who had been an activist and a teacher. And she said to us, way back in the 1970s, "Life is about the struggle." And that's just kind of a base for us. Life is about the struggle, and you just have to keep going every day, no matter how bad it gets. You have to believe, you have to have hope, and you have to understand if one thing gets solved, something else is going to go wrong after.

Blanche: What I say to my students, two things. When they are writing, unpack your heart. And no matter whether they are writing or thinking about what they're going to do, be bold. Those are the two things I say: unpack your heart and be bold. And then, with our friends, as we go from activism to activism, I say, we are shoulder-to-shoulder, hearts open, fists high. ▪

K

Kevin Burkett-Caudell

I've got a husband I've been with for thirty years. He's so very caring. When he's not around, it's like I feel like my right arm is missing. His family is from Madrid, Spain, and we like going to see the family there. They accept me and him for who we are. There's never been any issue with his family on that.

I was born in Ormond Beach, Florida, and raised in Titusville. My dad was not accepting at first. We didn't speak for a year, and then he ended up in the hospital due to aneurysms, and he almost died. He didn't want to see me at first, and then he agreed to see me. I didn't want him to pass away with any regrets as my dad. And after that I'll say we became best friends. I was the favorite child again. I had a good life with my dad after that. I mean, things changed a lot for him.

I was dating Nick at that time, so I think I was twenty-one. We met in Cocoa Beach, out at a bar, the old-fashioned way. The bar was actually in a little strip mall there. It's long since gone, but it's something I won't forget.

I lived in Florida until I was twenty-five, when I moved with Nick to the Chelsea neighborhood in New York City in 1992. It was very different then, but I didn't think anything of it. I explored a lot. My dad and family back in Florida were afraid for me when I came up here. They warned me: it's the big city, be careful. Before coming to New York, I didn't know anyone who was HIV positive, or who had died from it. I wasn't exposed to any of that until coming up here. I only found out later that some people in my hometown had it and passed away from it.

As a younger person, we did not have the same equality as younger people now: gay marriage, being able to be more out. Younger people are a lot more open about how they want to do things because of their parents. Everything is evolving, everything is changing. They can enjoy more. What makes me laugh is seeing other people happy. It makes me happy. Just the vibe, the energy of everybody being in a good place. Seeing other people laugh, children playing and having fun, not having a care in the world. Even in today's society, here in New York where you've got kids with gay parents, they don't think anything of it, and they're just enjoying themselves. There's no judgment. It makes you happy. It makes you want to laugh.

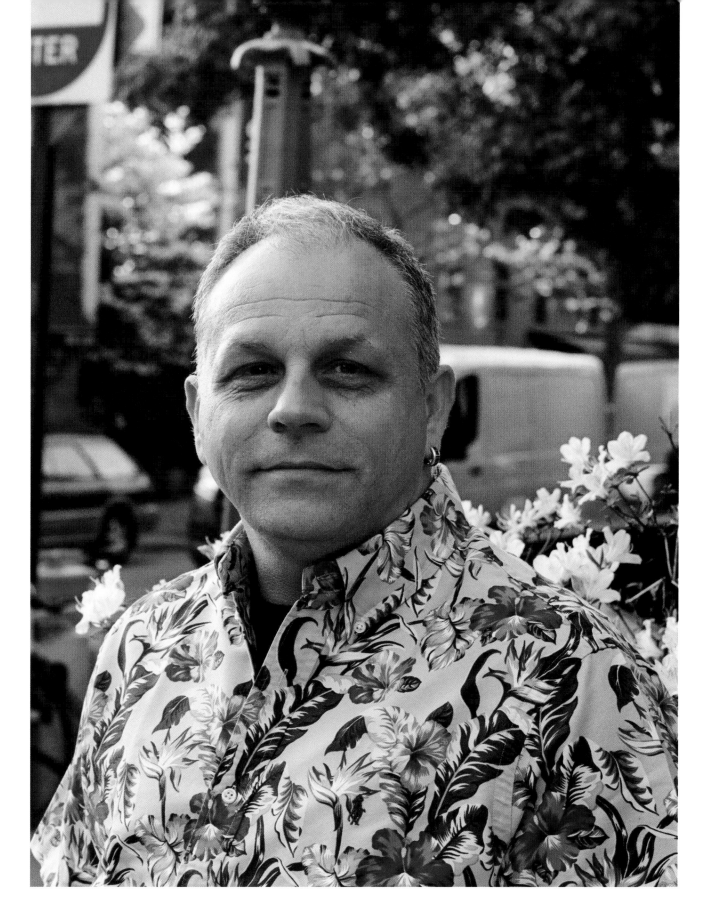

J

Joan Fong

I was born in Hong Kong. I came here when I was five. My whole family immigrated to San Francisco. I grew up there and went to school there. I came out east to go to college, and after college I moved to New York, eventually went to law school, and became a finance lawyer. Turned fifty, and then decided I'd had enough of finance, and maybe I should try to do some good. I landed at the International Rescue Committee.

I had lived in New York for thirty years until recently, when I moved back to San Francisco to be closer to my elderly parents. I had been talking about going home for a long time, but I never did because they weren't okay with me being gay. I had been in a relationship for almost twenty years with a woman. She was out, and she was never happy with me not being out to my family. I remember at one point I asked my sister, "You know, they keep asking me, are you not getting married because so-and-so's not getting married?" I said, "I think they know, right? They just want me to confirm, right?" And she replied, "No. You can never confirm, and you can never come home." [laughs] But it's all out, and eventually they came around and I was able to move back home. Now they're ecstatic to have me home. They even had been quite welcoming to my last girlfriend, and so all things are great on that front.

At the end of the day, I have no animosity whatso-ever for my parents because they really just wanted the best for me. Everybody has some tough time with their parents. But when you can say that they actually did it because they did want the very best for you, then you can forgive a lot. We were very poor. They worked in factories. They were just hoping that we would do better, and being gay is definitely a wrench in the works.

When I first started, I wasn't out at work. I was Chinese and a woman, so there was already a lot of stuff to battle with. But eventually I came out at work, and it didn't seem to have any effect. In my twenties and thirties, I spent a lot of time hiding. Hiding from family, hiding at work. Everyone has these fond memories of youth. I have much fonder memories as I got older, and, you know, feeling much more confident and comfortable in myself.

I spent most of my time being open with my friends. They say that gay families tend to be the family that you find and make. We have our own families, and not all of them were accepting, so many people come to the United States, to New York, because they weren't comfortable being gay at home. Thanksgiving comes around, and they're like, "Wow, what a wonderful holiday." Next thing you know, you've got all these gay people around a table, celebrating Thanksgiving, a very traditional American, family-oriented thing. They will start with "What do you have to be thankful for?" And everyone will say, "Happy to have my friends and family at this table." The gay community, they really do find each other and they hang on to each other.

I still think that love is the greatest thing. Hands down. Better than sunshine, better than any sunset. I think that the most important thing about love, whether it's love of a dog, love of a mother, love of family, a lover, all of it, is that we not distort it just because things don't work out. We have a way of changing love in our mind just because things don't work out or end. Love should be untainted by memories of loss. Love is in and of itself pure and, like I said, the greatest thing about life. ▄▄▄

Douglas Brooks

I grew up in central Georgia. I was very fortunate. I had a wonderful, patient, gentle father. His default was to be kind. My mother was very strict. She'd grown up in the Deep South, and her philosophy was that children were to be seen and not heard. But she loved us very much. My father worked really hard, and I was afforded a private school education and wonderful opportunities to learn and to travel and to have pretty amazing experiences. I spent life in Catholic school, K through twelve, in the Sisters of Mercy. It really shaped my life and gave me a foundation that I didn't appreciate until much later in life.

Life is so filled with paradoxes. One of the things I would say to the youth of today is enjoy your youth because it's fleeting. Have fun, enjoy life. At the same time, I would say find purpose. I don't think purpose has to be the same thing over the entirety of one's life, but I do think having some purpose and meaning is helpful. I struggled with finding purpose until my friends started getting sick. As authoritarian as she was, my mother had a deep, deep, caring heart, and no more so than when one of her own or someone she

continued >

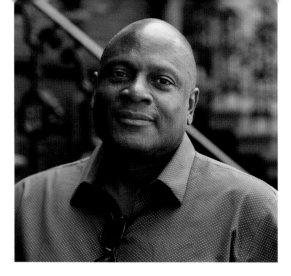

> > >

knew or cared for was ill, and so I learned from her to care for the ill and not to be afraid of the ill. When my friends started getting ill and their parents and their families didn't show up, and they were alone, I was honored to be able to help take care of folks. And it really started to shape a purpose for me.

I worked, just volunteering and helping take care of friends. After a period of time, I lost so many friends—this was in Atlanta—and I moved to Massachusetts, to Provincetown, thinking I was getting away. I landed right smack dab in the middle of this community where people were sick and dying all over, an incredible community of people who were caring for their own. I worked for the Provincetown AIDS support group and, at some point, realized that I did want to do it at a more professional level. Went to graduate school at Boston University, ended up getting a master's degree in clinical social work, and then went to work at this nonprofit, where I worked for sixteen years or so.

We grew up in a Christian home. Both my parents were in lockstep: their belief was that their Christianity was not to be preached, it was to be practiced. And that

meant service. Service in and of itself is a vitally important piece, but we exist in a world where there's a government and there are policies that impact one's ability to serve beyond family, beyond community. So I started getting involved in various groups and organizations where the focus was on policy, in particular around people living with HIV, and people of color, and people living in poverty. I had the great honor of running the Office of National AIDS Policy during Obama's second term. It was one of the most amazing honors of my life, to be able to do that work, with a wonderful team.

I don't think there was ever a time when I didn't know I was gay. There were times when I was very fearful, and I can remember praying so hard: please, when I wake up in the morning let this be gone, let this be gone. And it never was. And at some point I realized if God had meant for me to be different he would have answered my prayer and changed it. It wasn't without fear, and stigma, and being bullied. At some point I just decided I had to be me. I just decided I had to be my fucking self.

My mother said to me—I was home visiting her, and we'd driven into the driveway and we were listening to something—she turned the radio off and she said,

"Hold on a second. I want to tell you something. I want you to know, that after all these years of listening to and watching Phil Donahue and Oprah, and learning how many gay children kill themselves, I want you to know that I am so glad you didn't take your life while your mother was trying to get it." She was a brilliant woman, very, very smart, she read and understood. I'm a person living with HIV, and she actually asked me two times, "Are you positive?" And I said no, and lied, and she asked me a month later, and she said, "You know, I'm your mother. I would want to go through this with you."

When one can have it, the bond of love with the people with whom you've grown up, or with whom you share DNA, is a very special thing. What I also know is that when it does not exist—or even when it does—that people can also develop an impenetrable, loving, undeniable familial relationship with people with whom they have no shared blood whatsoever. And I've seen it over and over again, in many places, but in particular in the LGBT community, where people form family. I do think it's important to have some group with whom you feel home, that no matter where I am, these people for me are home and family. ▪

Sergio Cilla

I grew up in Argentina during the dictatorship, so it was a very dark time. I was conditioned to be a straight man, and I became what I was supposed to become: I had a girlfriend, I got married, I had children, and I loved my wife. We divorced twenty years ago, and five years later I came out. I was forty-two years old when I finally came out, and I said, "This is who I actually am." One year later, I met Martin in Buenos Aires, and we started a relationship.

The first person I came out to was my ex-wife. We met at a coffee shop, and I said, "I have to tell you something." And she stood up, she hugged me, and she said, "I'm happy for you because this is who you are." And for me it was like, "Wow, I got her permission." She's the mother of our daughters, and for me, it was very important. We still have a good relationship.

I have two daughters. It was probably a little harder for the older one because at that time she was seventeen—the younger was eleven—because she was in the last year of high school and she was worried about what her classmates would say. I think they didn't know what was going to happen, but it worked out well. My older daughter is now thirty-one years old. I have a grandson. He's one and a half years old. I love him. He's changed my life.

For me, love is being myself. Love depends on the type of relationship you have, but in a way once you accept who you really are, you come out of the closet in all ways in your life, not only sexually. Love is easy because you already love yourself, so you meet some-body, and you truly love that person because you're not looking for that other half to complement you. You are who you are. When I see young people, young kids being who they really are, I feel so much joy. And I think that is probably because it is what I didn't have. ▪

K

Kate Clinton

When people talk about "aging in place," I always wonder, "In place of what?" I am a grateful seventy-three-year-old, but with the wind-chill factor, it feels like fifty-nine. I am a lesbian, a proud LGBT feminist activist, and citizen comic. From small-batch artisanal farm-to-table laughter at dinners with friends and family, to serving up a main course of political humor at concerts and rallies, my great pleasure in life has always been making people laugh.

What I have learned about love from Urvashi Vaid, my dear partner since 1988, is that you show up for people. It's like getting the joke. You have to be there. And it would be nice if you brought some food, adult beverages, and a play-list for dancing after the protest or potluck. If I may give advice to the younger generation: let us hang out with your kids while you make older friends. Actually, call me. Come over. We'll watch YouTube videos of Kate McKinnon. She makes me laugh out loud, bang the table, and weep. ▬▬

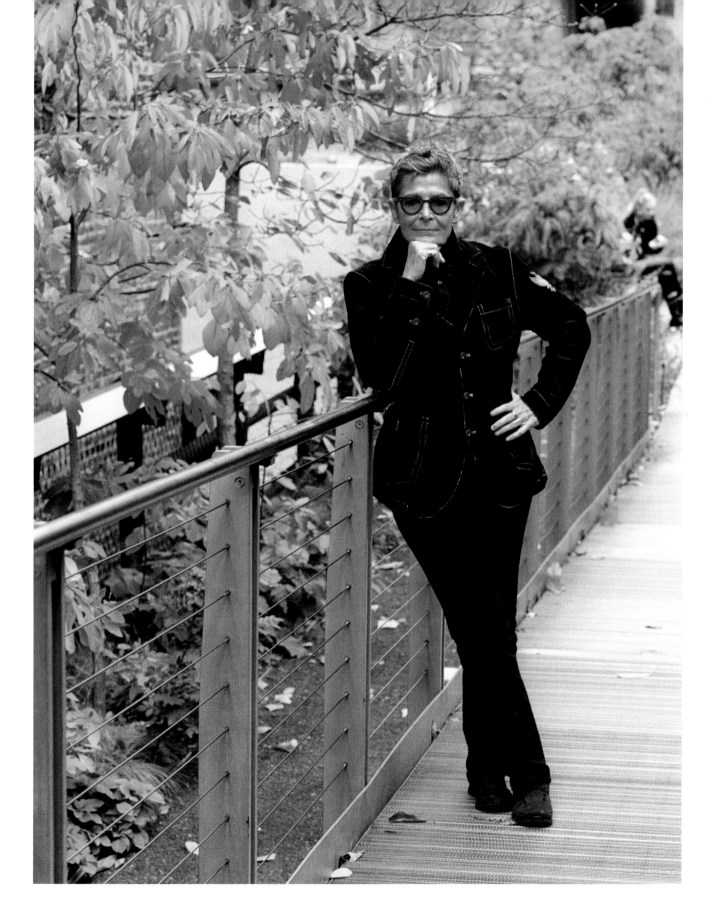

J

Joseph Negrelli

I was very fortunate that I had several people who really loved me very deeply. The first one would be my great aunt, who was not only my caregiver, she was also the matriarch of my family. With her I could have a long leash. She knew who I was, and way back in like 1957 we had a celebration at the house, and she publicly said that I'm going to make a great wife one day. I noticed that no one corrected her.

My biological parents died when I was seventeen, and there was a family who took me in as a foster child. They showed me great love and understanding and much more acceptance of my homosexuality, although we didn't talk about it. They showed love in many ways without defining what love was. And then I was fortunate enough to meet several men in my life who showed me a great deal of love.

I was born on a U.S. government installation while my dad was fighting in World War II. My mother thought that a government installation was a bad place for infants—at least that's what she told me—so we went off to Mexico, a mining town in the mountains. Then I came to the United States, to Connecticut, which was nice. It was scenically beautiful, but I could see that I was not made to grow up with cows and chickens and goats.

I came to New York. I went to trade school, then I got an opportunity to go to computer school. And that clicked for me, and I went into programming. I stayed until I had a heart attack, when I was fifty-eight. It took two years to rehabilitate, but I made it to sixty. During that time period I was volunteering at the Holy Apostles Soup Kitchen, and then someone told me about SAGE. I was a little busy, but I was going to go. Then I had another heart attack. So that set me back a little, and then I went, and they couldn't have been nicer to me. I felt very debilitated, I must tell you, by the heart attack. Emasculated, not that I'm very big on masculinity, but enough to know that I didn't want to be an invalid. Now they let me do the food pantry.

I am from the generation where there were heterosexual people who definitely tried to harm you, and there were also homosexuals who tried to harm you as well, like Roy Cohn. I hope I never understand them. They disliked homosexuals publicly. They raided gay bars and they prosecuted homosexuals, and they drank in places that they closed down. Roy Cohn may have gone to Stonewall. I didn't meet him there, but I met Roy Cohn on other occasions.

I would ask the younger generation to try to be their most authentic self. I don't think that there's anything more unattractive than a phony, and I have met a couple of people in my life that are phonies. Externally they're very beautiful flowers, but they're more like the Venus flytrap. They're a little too pretty, they exaggerate, not that it's hard to do in a society where money seems to draw a lot of things.

I lack a gay talent. I'm not an artist, I'm not a dancer, I'm not a great cook, a hairdresser, or a singer. But I'm really good at cleaning. I know I have that gay gene. I'm very clean, a semi-neat-freak. I live alone in a studio and people ask me how often I do the laundry, and I laugh when I remember that I've done it three to four times in a week. There have been requests for me to go and visit other people to get that out of my system. And you know what? It makes me happy. And it's a whole lot better than not washing your clothes. ▬

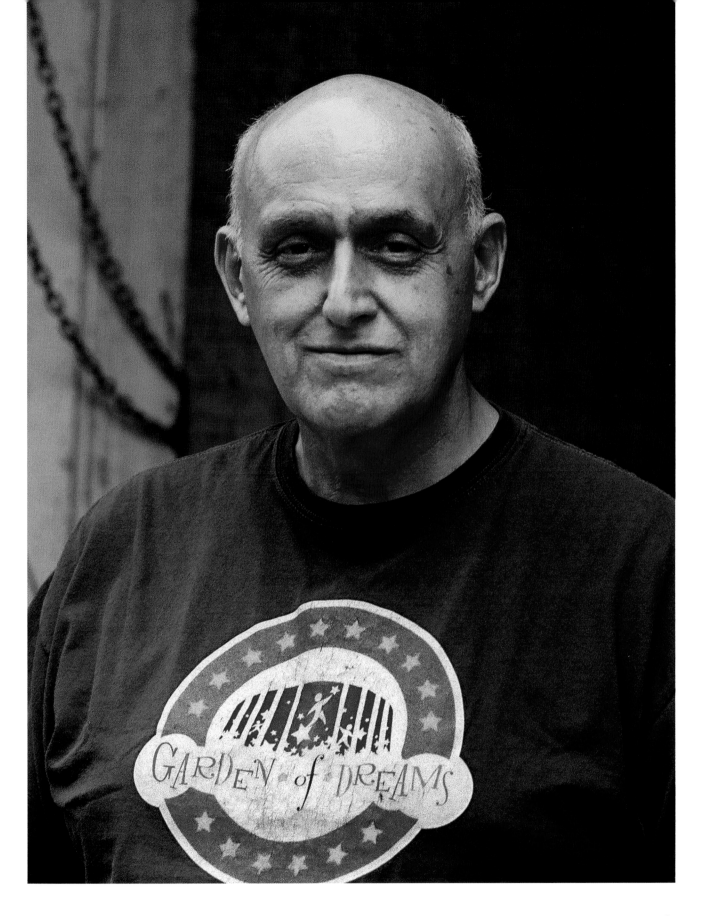

Genn Herley

I identify gender-wise as female. I was a heterosexual male, then I thought I was pansexual. Now I'm dating somebody who happens to be a trans woman also, so I guess we would consider ourselves trans lesbians. I guess that's what I would be. It's all brand new to me. Everybody has their label. For a community that doesn't like labels, we have a lot of labels.

I was born into a very large family, five boys and one girl. My background is mostly Irish Catholic, so feelings weren't really shared. You just went about your business. It was a tough upbringing, a tough family. My family had a big reputation. They were big into fighting with other people. Stereotypical Irish.

We lived in a town called Massapequa, on Long Island. The first time I dressed was when I was about eight years old, maybe ten. My sister was a Brownie, and I had this neighbor, and she decided to dress me as a girl. My mother had six or seven wigs, and what is shocking now when I think about it is my mom let me dress that day. I went out in a Brownie outfit with wig and makeup. I went door to door to the neighbors, and I loved it. When I got home, my mom insisted that I take it off. She was worried that my dad was going to come home and see me—or my brothers. I remember trying to confide in her, and she'd have nothing to do with it.

I ended up burying that for years and years. I did what a lot of trans folks do. You end up having repressed anger. You're angry inside because you really want to be somebody else, but you're not ready to let it out. For me, it led to a lot of substance abuse, a lot of alcohol abuse, and I just put that part of myself away. But it would always sort of like come out in certain instances. I remember as a boy, when I was like thirteen, I used to go fishing. In order to fish you had to get bait, so I walked to the food store. I remember it like it was yesterday. There was this little dress shop with a big

continued >

> > >

picture window, and I walked by those dresses every time I went to get bait, and my heart would just pitter-patter like I was in love. It really stayed with me . . .

When I graduated high school, I met my ex-wife. She was seventeen, I was nineteen. We fell in love right away. Her parents were very strict, so she had to be home by twelve, so the only time we could be intimate was in a car, and then from the car we graduated to short-stay motels because I was working—I'd dropped out of college after a month. She was fairly open to things, so she used to buy lingerie. I stored it in my car and one day when I was nineteen or twenty, I was like, I should go to the hotel and put her lingerie on. I don't know why, but I did it, and I was sky-high when I did that. At the same time, I was scared because I didn't understand what the hell I was doing. And then it almost became an obsession.

We were together seven years before we got married. I was cross dressing on and off, and each year it was accelerating. I went to a therapist, and the therapist said to me, "You got to go home and tell your wife, then we'll work this whole thing out." I was so frightened. I was madly in love with her, I still didn't understand what was going on with me, I was afraid I was going to lose it, so I said, "I'm not doing that," and never saw the therapist again. I looked for another therapist. Finally I found somebody, and the truth of the matter is I've been working with her for twenty-seven years straight. She helped me get back to school, she helped me earn a PhD, in psychology. I went to school at thirty-six and finished at fifty-two. All at night.

I'd always worked in plumbing. I still work in plumbing manufacturing. I own a small decorative faucet company. I also opened up a small counseling business, working mostly with the trans community. I was going to conferences outside of New York. It was a lifesaver. They were conferences for people who are in

the closet. Most of the transgender community is still in the closet, probably 50 to 60 percent of people in some states. Maybe they'll never transition.

I was working with people in the trans community, but I wasn't out. I was working through it with my own therapist, but I was helping people talk about their own issues at the same time. I would get to know people and hear their stories, I'd start to understand we're all human, we all have our issues. You might think it's weird, somebody may not. We imprison ourselves, for fear. You had so much fear.

But not anymore. I came out a year ago. For me it's been a radical change in the course of one year. The big thing I've learned by coming out is my energy level has tripled, it's off the chart. I'm doing so much all the time. When you're suppressing yourself so much, it takes the spirit out of you. Now that I'm free, I feel fantastic about it.

Leading up to coming out, to my family, my really great friends, was frightening. I went into it thinking I'm going to lose everybody. The only one who I couldn't deal with losing was my daughter. If I'd lost her, I'm not quite sure I would have been able to do this. But I was prepared to lose everybody else. I was ready to just say that'll be it. But I didn't lose one soul. Not one soul. And I gained a whole LGBT family, which to me is the bomb. There were so many people trying to help me in every which way, and I just never in my life expected that. I wish I had known that when I was worried about losing everybody.

Fears don't end up turning out the way you imagine. You always fear the worst. I certainly feared the worst. I'm not trying to give anybody any false impression that everything's always going to be flowery, but I think that if you go about it in a humble way, you'll be fine. For fifty-seven years I lived in fear of being who I am, and now I wake up every day and it's a breath of fresh air. I have a zest for life that I've never had. I don't need to numb myself anymore. ▬

K

Kate Conroy

I identify as a lesbian now. It went through a progression. I was raised thinking I was straight, and then I started having interest in women, and so I identified as bi, but that wasn't very popular at the time. When I committed to being with women, I identified as a gay woman. A lot of it was resistance to the negative stereotypes of lesbians, as if it were all about hating men, as if it were all about not shaving, as if it were all about not wearing a bra, as if it were all about flannel shirts and ribbed tank tops, and all of that. Which I didn't identify with. I was the straight girl who started dating women. "Gay" was okay, even though gay men were very dismissive of lesbians. I hung around a lot with gay men in clubs, so the more femme, the more like arm candy you could be to the gay men in a club, the more acceptable you were.

I grew up in Portland, Oregon, but then I moved to Boston. Portland was super crunchy, very hippie. The Boston area kind of had that in Cambridge, but where I went out was more like Back Bay, and the women I related to on a superficial level were very much wearing makeup and all of that. Some people there would just say they were gay, but then you would go to Province-town and people used *lesbian*. Because of some of the earliest pride marches, and then all the centers that opened up were gay and lesbian centers. So then we were like, okay, we can distinguish ourselves from the men, we don't all have to be gay. We were the lesbians, but we weren't *those* lesbians, we were the lipstick lesbians, right. It never really felt natural to me, but that was my social set, so I just went along with them. Some of the men in P-town, they liked to call us lipstick dykes because they loved saying the word *dyke* and hated using the word *lesbian*.

I'm in my mid- to late twenties during this time, and then, finally, when I was twenty-seven or so, I moved to New York, and I kept that sort of aesthetic up, as long as I could afford to. Then I couldn't afford to. At the time, there was an acceptance of the androgynous lesbian. We're looking at the time when k.d. lang was on the *Vanity Fair* cover with Cindy Crawford. I tried that for a while, but I didn't really have the body for it. A tall, skinny person can pull it off really well, right. I don't like to do anything unless I can do it really well.

Then I just stopped wearing makeup, and I cut my hair short and wore tough-girl jeans and vests and motorcycle boots. My first New York march was like that—black bra and a vest and white jeans. But then nobody was noticing me as a lesbian, so then I started thinking, "Okay, I have to start indicating by my dress that I'm gay." Because I wasn't really into the rainbow flags, I wasn't really into wearing the accoutrements. I was very naive. I just want somebody to know me without my having to tell them.

I then had what I call my own butch phase, and then I met my current partner, who's an old-school butch, she wears a flattop, doesn't own a stitch of women's clothing. By comparison, I was femme. It's funny because even within the relationship—and we're together twenty-some years—the idea of the femme and the butch is limiting. I mean, she cooks, I fix things; it used to have a very strict definition in terms of bedroom behavior. It's ridiculous. I'm always resistant to any kind of stereotype. I don't like labels. There are more labels now to pick from, but they're still labels that are off straight. They're all just whatever's not heteronormative. ▬

George Calderaro

I was raised in Connecticut. I grew up working-class in an affluent place, in a Section 8 housing development, and it took years to discover that emerging from that and succeeding and being the first in my family to go to college was something to be proud of and not ashamed of.

I had an excellent relationship with my parents. It was wonderful. They didn't like each other, but I had a great relationship with both of them. They stayed together, probably for money, and they were Catholic. It was tragic for them. It was fine for me. They would take us to the theater and do things. And since I was the youngest, I did it for the longest amount of time after my siblings became too old and it wasn't cool to hang out with your parents.

I feel as though I always knew I was gay, and I think everyone else knew. It wasn't discussed, and it wasn't anything that was especially public, but I did tell my parents. They knew, and they thanked me for telling them, but it was not an issue, with them or any member of my family that I know of, immediate or distant. And I didn't really experience a lot of homophobia except for one gay-bashing in New Orleans, but I was working in arts, in theaters and in museums, so it was a nonissue. My sexuality never inhibited me.

I haven't been with a lot of people. I've had a lot of long-term relationships, but I think that I've learned that you have to be with the right person. And I think I am with the right person, and the right dog. My friends, like a lot of gay people's friends, are your family, although I just came back from a family reunion and it was all fine—they know me, they know my husband,

they know my dog, they know everything, or enough, about me. But since my family is not in New York, I don't see them on a daily basis by any means, so my friends, my networks, become my family. Then, I'm so involved with nonprofit organizations and charities and preservations, my colleagues and my counterparts become very important. I started working at the Landmarks Preservation Commission in 1993, and it's great.

Lifelong learning brings me the greatest joy, and that can be defined in the broadest way possible. But particularly history. I realized that my interest in preservation is really an interest in history. My interest in art is really an interest in history. Who made this, when was it made, why was it made, whether it's a building, whether it's a performance, whether it's an artwork, because these are our clues, or our wayfinders to society, humanity, and ourselves. And, you know, it's a cliché, but those who don't know history are bound to repeat it

I read an article in the *New York Times* by John Leland. There's a writer who interviewed people over the age of eighty. He did dozens of interviews with people, and there were three takeaways, in terms of having a rich and rewarding life. Probably the most important is empathy, compassion. The other is pride, pride in who you are and what you are. And the other is gratitude. I think those were the three big takeaways, the things I would like people to keep, empathy is huge. Years ago, I came up with a philosophy that said never resist the temptation to do something nice. You think about calling someone or sending a note, just do it. It's so rewarding. ▬

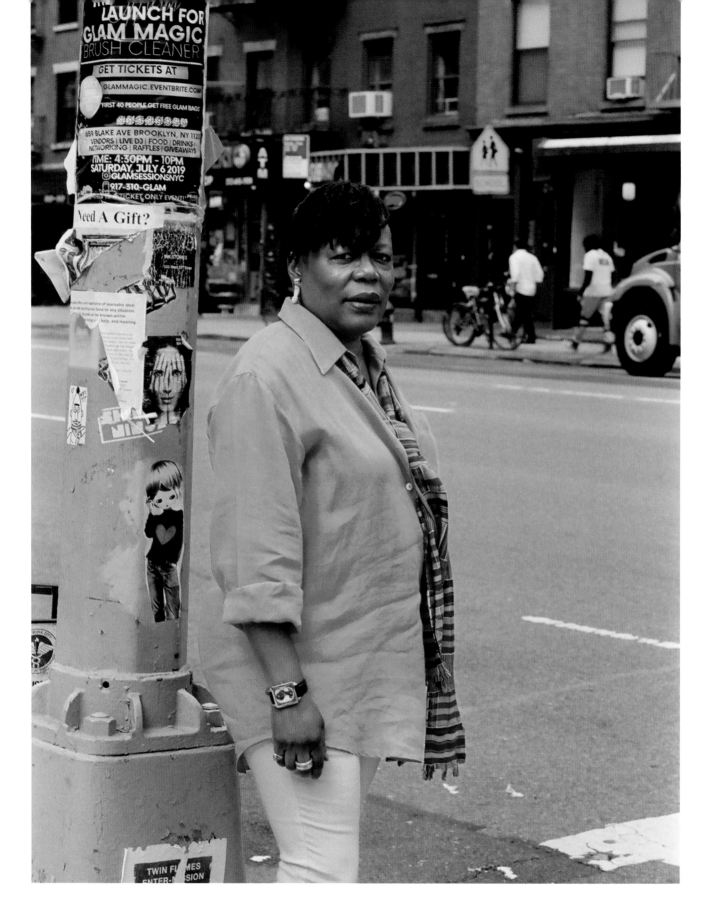

G

Gwendolen Hardwick

I've lived in New York all my life, raised mostly in Brooklyn. Both my parents were from the Deep South, Georgia, but they didn't meet each other until my mother came to Harlem on a kind of vacation, a gift from her brother who lived here, because she had made valedictorian of her high school. He convinced my grandmother to let my mother come to New York. He'd take care of her and watch over her, and she'd go back and go to college. She got to New York, saw the bright lights, the big city, and she didn't go back for many, many years.

My father worked at Macy's for many years. He was a butcher and then a cook in its Patio restaurant. My mother was a stay-at-home mom until I entered junior high school. I have a sister who's five years older; it's just the two of us. When we moved to Clinton Hill in Brooklyn, we were maybe just the second Black family there. By the time I entered the same junior high school as my sister, it was about 50 percent Black. I had

a very different experience. I was very active in school. I've always loved the arts, and I would write plays, and I would cast my classmates.

I never, at any point, said, "Oh, I'm coming out." When I think about my life, I was, I am, just me. I'm me. There was no trauma in my life on that level, except when I stopped speaking to my mother when I was around twenty-six or twenty-seven after I moved in with my partner. I had been working and living on my own at least five years by then. I moved out because she asked too many questions about everything. She didn't even like me listening to Nina Simone. I was a revolutionary very early.

My whole life has been in the arts. I did not know where it was going to land me, but I was able to sustain myself as an artist on different levels. I co-founded a theater company with Alexis De Veaux, the Flamboyant Ladies Theatre Company, in the mid- to late 1970s, and for thirty years I've worked at NYU and CUNY. I loved the work, but it was very intense.

continued >

> > >

I trained up in Harlem, at the African American Studio for Acting and Speech, and even though I graduated from Tisch School of the Arts at NYU, I say that I got my training from the Black Arts Movement, the cultural arm of the Black Power Movement, and my exposure to other Black theater companies in Harlem like Roger Furman's New Heritage Theatre or Barbara Ann Teer's National Black Theatre. I met Alexis during this time. She was a playwright. She gets her play, and they need an actress, and I get the part in one of her plays. That's how I met Alexis, and we've been friends ever since.

I love to laugh. My early days in school, when I was writing plays, the stuff would be so funny. But in time, that changed. I mean, I had teachers who thought I was going to go into comedic acting. But I didn't. I allowed myself to be affected by the changes in the world. And at that point, when I went to college in 1969 in New York, it was a powder keg. The Black Power Movement and the reaction to it. When I went to Brooklyn College, I didn't go into theater. I majored in history and political science. Theater was not something the movement gave you a sense that you should be doing. What the revolution needed was historians. We needed political education.

I dropped out of Brooklyn College. I discovered that I still loved theater. There must be a way that I can use theater to activate myself to be in the movement in a different way. I knew that commercial theater wasn't the venue, although, you know, they got my pictures and resume like everybody else, but there was just something in me that always knew. That's when I found educational theater. That's where my loves of both education and theater could merge. And then I could activate revolution through the act of drama, and train actors. That's when I got involved.

The thing that educational theater allowed me to do was to work with young people. I got to design educational theater pieces that went right into the schools. We dealt with social issues. The whole mission of the company was to address social and curricular issues through theater. And so that's what we did. I directed and designed curricula and trained teaching artists. By the time I retired, I had been the company's artistic and educational director for five years.

I'm now trying to write about that work, and still mentor young teaching artists whom I've minted in the work that I just love. There are just some amazing young people out here. People talk about young people in very negative ways. I don't know who you are looking at, but we have to stop doing that. There are some amazing, young, talented people who are just brilliant and creative, and they want to make a difference in this world.

I've gone to events, particularly in the theater world, and I get annoyed with people in my generation when they say: "Young people don't know how easy they've got it" or "They don't know whose shoulders are holding them up." And this is particularly in the civil rights movement, the human rights movement, the sense that young people don't appreciate that there were movements before them. Even in the theater world, the Black theater world, there's the sense that young people don't appreciate there were movements before them that allow them to feel this sense of freedom. And I say, "You know what? If they don't know, it's because we haven't told them." That there is our responsibility. So my words would be to people in this older generation to embrace our young people, and if you think there's something they don't know, then mentor them, then be a part of their lives, then, yes, stop complaining. ▰

J

Jamey Mangum

I grew up in South Carolina. I had a lovely childhood there. Didn't stray too far for school. I followed my sister and went to the College of Charleston. I loved Charleston, wonderful people, a land of eccentrics. I had been raised in the Bible Belt of South Carolina, with the fear of God, the fear of going to hell, so moving there was probably one of the best decisions I ever made. It was a great grooming ground for me, being a young, gay male, and I was able to meet a circle of great people there. I was always around older people, five, ten, fifteen years older, so when I came out, I had the luxury of their knowledge, of what they'd gone through, to help me.

When I finally came out to my mother, I'd already left South Carolina, and I was living in DC. My sister is a lesbian, and our parents had suspicions about each of us. I'd been asked many times by my parents what I knew about my sister, and she was getting the same questions about me. At some point, my sister's like, "She's asking this, she's asking that." I'm like, "Tell her." She's like, "It's not my place to tell her anything." So I called my mother and ended up coming out to her. And it was surprising, for being such a religious household. She was very understanding, and much to my surprise, she took it upon herself—my parents weren't living together by then—to join PFLAG. I mean, my mother wasn't happy about it. I came out in 1987, at the height of the AIDS crisis. That's the first place where her mind went.

I went to work for Ralph Lauren in 1988, and with my work I was asked to move to New York, and then to Washington, DC. I moved to DC in 1991, and in the early spring of 1993 I met Eric. I was in a relationship at the time. But we met one Sunday evening, we shared a glass of wine with a bunch of friends, and I was enamored. Seven days later, I left the relationship I was in, and we've been together ever since. We're from two different worlds. He's from a quiet midwestern Reform Jewish family. He was raised on Long Island but really raised in Cincinnati, Ohio. I'm from a crazy, Southern, highly religious family from South Carolina. We're happily married now. We've been married since 2016, but this year will also be twenty-six years together. Half of my life we've been together.

For some time after my sister came out, we were known by all of our friends as having the coolest mother in town. All of our gay friends loved her, and she just embraced everyone. Fast forward to 2016, my mother's gone full circle. The election of 2016 exposed a side of my mother that I guess she had suppressed. It's given her the comfort level to be outspoken, and now, as an adult in my fifties, I'm dealing with what I was lucky to bypass in my twenties. She used to be so supportive, but now I interact with someone I no longer know. Her response to the fact that I was engaged wasn't warm.

My dad is from a farm community in South Carolina, but somewhere along the line he became the most understanding, liberal Democrat, and even though they had never met, he never hung up the phone call without asking, "How's Eric doing? Give him a hug. Tell him hello." And we never had the conversation. You know, you go through life and you reach a point you have an understanding. Our relationship was good. I didn't need to throw a wrench in it. Eric only met him four months before he passed away, after we had been together for twenty-four years. And I only learned at the funeral from my stepmother that that was the best day of my dad's life, that he finally got to meet him. ▬

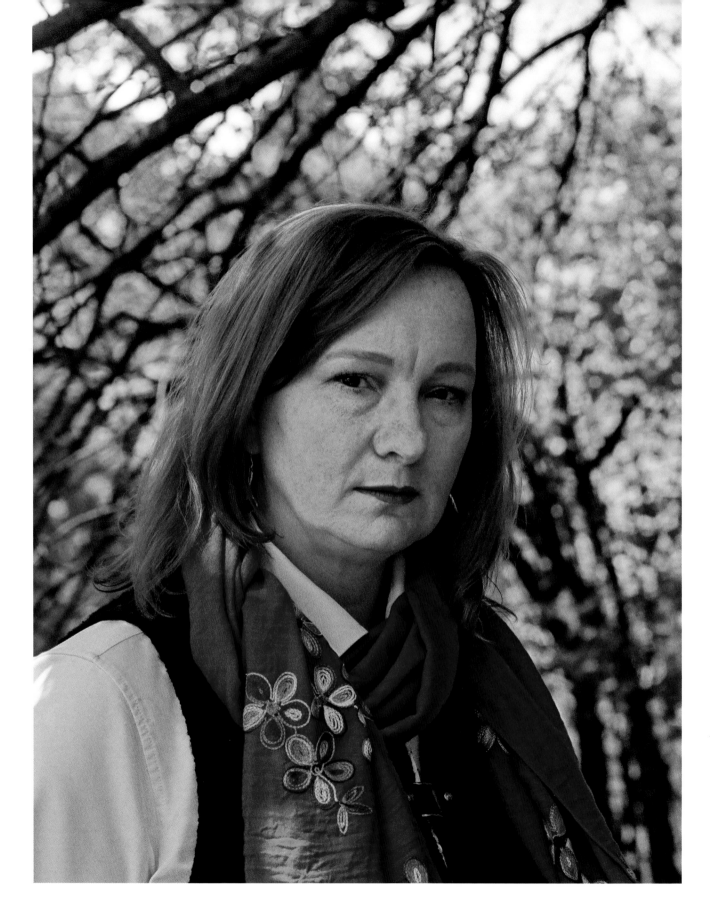

Maryellen Novak

When I was a kid, we used to lie down in the backyard after playing with the neighborhood kids, and we would look up at the sky and the clouds. I realized a few years ago I started doing that again, looking. I'd forgotten to do that. And so now I challenge myself as I'm walking, I'll stop and I'll look. I would say that when you find opportunities to be alone, you should learn to really enjoy those moments, then you become a much stronger and smarter person. You'll never be "lonely." I love traveling alone, I love being by myself, but I also love being around people, so it's just, it's a nice balancing.

I didn't come out to my parents actually until I was forty. I was married. I was married for five years. I have a son. He's twenty-nine now. I told him before my parents. He's a wonderful, wonderful man.

I've spent a lot of time over my life thinking about love. What do I love? I love being in blankets, I love being warm, I love my pets, but as far as a romantic love, I think that's not for me. There is nothing there. In one of the last scenes in *The Wizard of Oz*, Dorothy is looking in the bag, and he's pulling out the heart, and all the other stuff, and they say, "Oh, there's nothing in there for Dorothy." I feel like that. There's no love in the bag for me.

I'm involved with Rise and Resist and Gays Against Guns—they started up right after the Pulse tragedy. Shortly after the 2016 election, I was out there looking for something to connect with, and GAG was full of passionate, wonderful, positive, smart people that I really felt an instant connection with. It was the same thing with Rise and Resist—they came from ACT UP, so the skill set, the knowledge, is fantastic. It can be intimidating, but I just soak it all up. It's completely transformed me. We get arrested, and I know they have my back and I have their back. I thoroughly trust them, and I've shared things with them that I've never thought I would share with people before.

In January 2017, I was at my first Rise and Resist meeting, and someone got up to the front and she said she had acquired these tickets to the president's inauguration. I'd never done a civil disobedience before, didn't even know what that was. I ran up right to the front. The day before the inauguration, we all met, a dozen of us, and we figured out a plan. We sat for six hours right near the front with Trump supporters, and when he started to take his oath, that's when we jumped up. We had these power whistles and signs, and we ran right as far as we could. We started shouting, "Not my president!" and then the police came and took us out. If you go back and you listen to him start to take the oath, you will hear our power whistles and our yelling. That will always be my proudest moment. The fact that they'll never be able to listen to that without hearing that disruption, it just gives me chills to this day. It was fantastic. I haven't looked back since. ▬

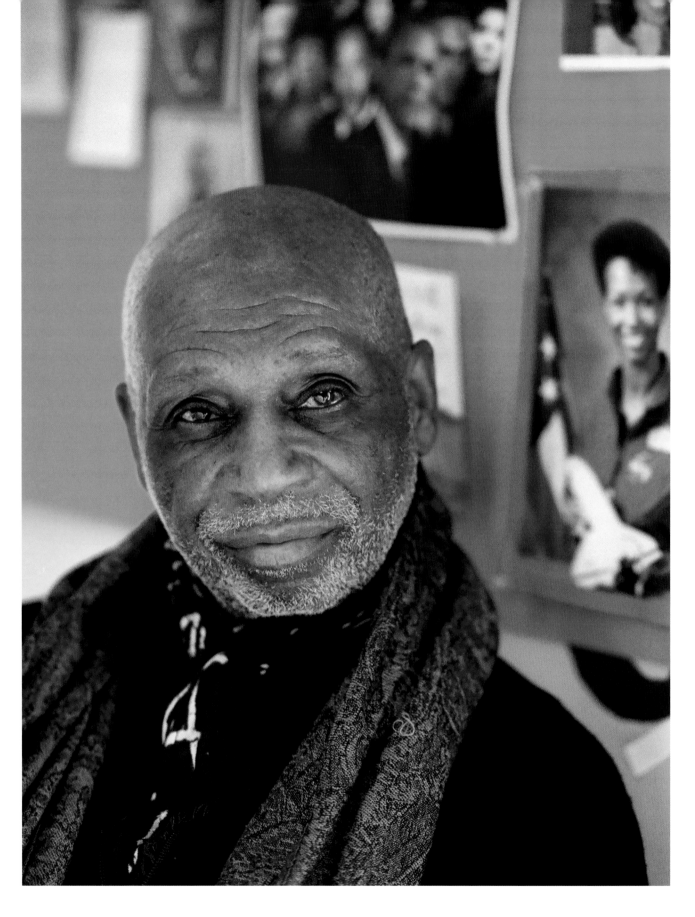

H
Howard L. White

My art has been my savior. I do collages. I work in everything: glass, copper, wire, paper, scraps of material. I have a thousand magazines from about 1950 to the present, and I cut things out, put them together. It amazes me sometimes. My art brings me the greatest joy in my life.

It's been a rather long life. Started in 1940, and it's continuously growing. It's just been a marvelous experience. I've been in Chicago most of my life. I grew up as an artist. On the South Side of Chicago, there's not a whole lot for you. I was in my own world. If it wasn't for the Art Institute, or the Museum of Science and Industry, or the Chicago Historical Society, I would have been lost. Those places really influenced my art. I would take a big tablet of oatmeal paper and my tempura paints, and I would spend all day in the museums. And that was my world.

I was not especially athletic. I was more of a nerd. People ignored me, and I liked the fact that people left me alone. I had an aunt, a great aunt, God rest her soul, Clarice. She was very, very strong. A lumberjack kind of a lady. I remember she had to defend me against a lot of the people in my family, particularly my cousins, my sisters. They were saying little derogatory things to me. In high school I realized, "Howard, this is who you are. Really none of anybody's business." I learned that from my aunt. We all have our own idiosyncrasies, and you don't share who you are with anybody. How you feel is your own business. So I took that and ran with it.

I've always been who I am. I've always felt as I've felt. I remember going to the movies and falling in love with John Wayne, and Randolph Scott, and Jon Hall, and Tarzan.

Went in the military from 1963 to 1966. That was my right of passage. There was a sergeant that did not particularly like me. Redneck, was from Kentucky, but boy, he was a dead ringer for Burt Lancaster. I said, you know what, that's some action I'm going to tackle before I get out of this army, and my last day in the army, we got together. Shit happens.

Got out of the military and went to art school. I got married, stayed married for thirty years. Bought a house. Had a little girl. The first baby died after a seven-month pregnancy. I looked at people that were married. I watched them fight, love, throw potato salad at one another, throw transistor radios at one another, and they were still married. We didn't fight along that line, but I had family issues on my wife's side.

I did what I wanted to do. I'm not going to lie to you. Yes, I was on the down low. I had guys who were looking at me left and right. I said, "Well yeah, but like, maybe, but not hardly."

My wife and I, we were very happy. I did everything I could to keep the marriage alive. I told my wife, I said, "Well, sweetheart, you're married to me. I'm an alpha male. I can do what they do. My body's just as good. In fact, my buns are better. I'll dance for you. You think I'm kidding." In my living room, I took off my clothes, off to my underwear, and I stripped for her, and I danced. She said, "I didn't know you looked like that." I said, "Yes, you did. Oh, yes, you did." And I danced for her. I danced for her around the living room. You have to be spontaneous if you're going to be married. You have to be spontaneous.

Ray DeForest

I'm 97.6 percent Irish, more Irish than people living in Ireland. Grew up in Staten Island in a classic middle-class household. Mom was a model in the late 1940s, early 1950s, she was beautiful. Dad was the athlete. He worked for the telephone company, started out hanging lines and ended up vice president of the union at one point. Worked hard, believed in working hard, believed in family and doing what was right. They were great parents. They were tough on us, me and my sister.

When I came out to my parents, I was sixteen years old. They could have cared less. My dad said basically, "Okay. Can you pass the gravy?" I thought, "That's it?" Then he came into my room after dinner. I was in my room, shaking. And he came down and sat next to me, and he said, "Are you okay?" and I said, "Yeah." He said, "Are you happy?" I said, "Well, as happy as a sixteen-year-old can be." He said, "I know it's not easy being gay, and if you ever need anything, you just know we're here." This was 1975. My soul just grew that day, and it never stopped growing. That was a kind of unconditional love I didn't understand at that point in

continued >

my life. And my sister, who was only four years older, came into my room and said, "I'll love you forever." And she did until the day she passed. Mom cried every now and then. I remember for a long time she didn't want to tell her friends. She would make up stories, like, I had a girlfriend. She said, "I don't want them saying anything bad about you." I finally said to her, "Mom. They know you're lying. I'm thirty-five. I'm a decent-looking guy. I've got your genes. They know you're lying. And if you're lying, then they think you don't accept me." Then, about two weeks later, I get a call, and she says, "I just want you to know, I was out having lunch with the ladies, and I told them I have a gay son, and I'm proud of him."

I grew up a typical gay kid growing up at that time. Just didn't fit in. But I was a star athlete—I was a swimmer—so people were nice to me. I learned quick that there's no better way for people to not say bad things about you than to be important. So I also ran the newspaper, I was head of homecoming, I was the editor of the yearbook. My parents taught me well. Be in charge, and they'll be nice. They'll make fun of you behind your back, but you won't have to listen to it.

I went to the University of Maryland for three years. I got a job offer to go to Disney, and I quit. Moved to Florida and never stopped working. I became an actor. I never had a boyfriend. I didn't have time. I was like, "I'm going to be an actor, and I'm going to work." I had lots of sex before HIV and AIDS, and then that happened, and everyone I knew died. People have no idea when we talk about that time, unless you lived it. Unless you do, you don't know the pain. And of course then there's survivor guilt. I had really bad survivor's guilt for a long time because I'm not positive and I did everything that everybody else did. I don't know why I'm not positive. Then everybody dies. You go visit them because nobody else will. I remember going to St. Vincent's and doctors and nurses wouldn't bring them food. They were afraid to walk in the room.

When I was thirty-five years old, I immediately got a job in television, on a morning show. I was a hit, and I was on TV for like ten years straight. When I was forty-five, I got fired from the Food Network because I filed a sexual harassment suit because they used to call me faggot and queer at big corporate meetings. When you're talent, you're just supposed to smile and say, "Okay, fine," and I just couldn't take it anymore. I'd had it, and I went to court, and we settled out of court. I got blackballed from the business. I couldn't get a job.

I have a husband. Well, I call him my husband, but we're engaged. We have our Aquaman rings. I was the sketch model for Aquaman for DC Comics for years. My dad and I used to sit and read his old comics when I was a kid, it was a bonding thing, and Aquaman, that was my thing. So I got these Aquaman rings made as our engagement rings. Then when marriage became legal, everyone said to us, "I can't believe you guys didn't get married. You're the ones always marching." And I was like, "Well, here's the thing. I grew up at a time when having kids and getting married were absolutely not part of the dream. For every gay man that I knew who was older than me who was helping me be who I was, it was not a part of who we ever thought we would be. So, all of a sudden it becomes legal, and it's like, 'Well, I'm happy that we have the legal right, but is it necessary for us on a personal level?'" On a legal level probably, so we're engaged and we always say, "Yeah, we'll go to the courthouse one day when we have a few drinks and just do it, and we're done."

Life makes me laugh. I laugh at everything, at myself, at my husband. He's awesome, he just allows me to be me. No judgment, no questions. I'm an actor, so, I admit, it's a roller coaster. One day we're up, the next minute we're down. And I will be in the kitchen—I love to cook—and I'll start screaming, "Goddammit, motherfuck." And he just pokes his head around the corner and says, "You sure you're okay?" "Yeah, I'm okay." He goes, "What happened? Bread crumbs in the wrong place?" "Yes, how did you know? It's so stupid." Then I just laugh because it's absurd. And he laughs, just like go, let it out, it's out in the world, more room out there. ▪

Deborah Meyers

I grew up in a middle-class, Jewish household in Queens. My parents were divorced around 1968, which at that time was rare in my area. Divorce was not popular, unless you lived in California. My mother, my brother, and I moved to L.A., and my father remained in New York, so my junior high school and high school years were in California. When I was eighteen, I came back to New York and lived with my father for a brief period of time. It was difficult. My dad was definitely a bachelor dad and did not want an eighteen-year-old daughter living with him. I was in acting school at that time, then ran off to London, did acting school there, then tried to do some acting. I went to college at twenty-seven, where my first two courses were remedial math and English because I wasn't really *in* high school when I was in high school, and I wound up graduating summa cum laude, Phi Beta Kappa. Then I got a scholarship to Harvard, where I studied theology, but not knowing why I was doing it. It wasn't as if I wanted to be a professor or a minister. It was more about self-knowledge.

For my first year of Harvard, I was married. We were married for only like two and a half years. He had a drinking problem. I took off for a year, slept on my dad's couch, worked two jobs to earn enough money to go back, and then finished my second year. In my late thirties, I decided to try acting one more time, so I did that. I was doing better the second time around, but then I saw an ad for a product demonstrator at the children's toy store FAO Schwarz. I got the job, and one day they had me selling beading kits. And I'm beading a pair of jeans, and it just felt really good, so I thought,

"I'm gonna go to a beading store," and one thing led to another and I started to make jewelry. That's been the thing that has felt right for me. I love it.

I spent, let's say, zero to forty being straight. I came out late, and I was terrified. I thought, "Oh god, not this too," because I've had mental illness, I suffer from depression, and I have a challenging background, and I thought to myself, "Another thing to have to examine, work through, blah blah blah." But I thought, "I've got to do something." I found this coming out group. They met like once a week. Then I thought, "Well, I should probably find myself a lesbian therapist so I can just talk about some of these things," and I found someone to work with.

I will say that my second year at Harvard I was around a lot of lesbians because I was studying feminist theology, and the Episcopal Divinity School had some very well-known lesbian Episcopal priests, like the first woman priest and the first group of ordained women who were out. So, it had been something that I was questioning very much during that year.

I didn't have a problem having sex with men. It was really about an emotional connection. And I didn't want to have to play the girl. I didn't want to have to be not as smart as I thought I was. I was very proud that I had gone to school and did well because I worked really hard for my education. And some people said maybe you shouldn't talk about it that much, because it could be intimidating for people. And I was like, fuck you. I earned this. Not in a bragging way, but I'm proud of what I've done. ▬

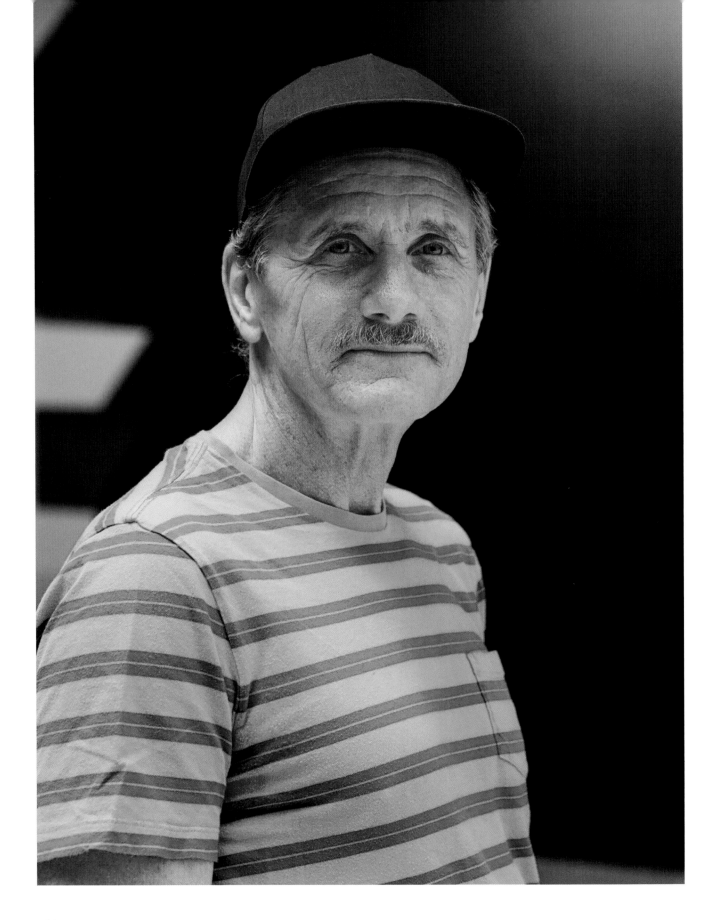

J

John Laughlin

I was born in Portland, Oregon, and I grew up there until I was eighteen, when I came to New York to go to art school. That was in 1975. In Portland, I knew I was gay, but there was sort of no context for being gay. I went to an all-boys Catholic high school and was made fun of constantly. The minute I was in New York and in an art school, there were tons of gay people. People talk about coming out, but I don't really feel like I ever came out. I just suddenly was put where it was okay. It didn't really matter. It was like nobody cared. I never did tell my father, but we weren't close really, and he died when I was twenty-four. My mother I told I think the second year I was here, in 1976.

I don't really feel like there is much of a gay community anymore. I miss that in some ways. When I came to New York, the center of the gay community was Christopher Street in the Village, and then it's sort of moved north to Chelsea in the 1980s. Chelsea now just seems rich. Everything seems about money now, and the gay community has sort of just been absorbed into the mainstream. It's a good thing in one way, but in another way I feel like it sort of took away everything that was special about it. Maybe it's what had to happen to make it freer.

It's like marriage. I am married, but I'm not really a big fan of marriage. I mean, I'm only married because it made more sense insurance-wise, asset-wise, that kind of thing. I find it funny how everybody's getting married, and then you have to listen to people getting divorced. We wanted nothing to do with any of that at one time. But other people see that as total progress, so I don't know.

We live in a world where we talk about love constantly, but I don't think we really say much about love. It's just like everything is love, love, love, love, love. I think I know less about love now that I'm older. Love is a very complicated thing, and it's all kinds of different things. I mean, there's familial love and there's the love of my friends. There is physical love, there is emotional love. There's the love of my friends, my sister, my partner. There's people that I still love that I don't see any more, but they still hold a dear place in my heart. And there's people that are gone that I still love and miss. Love can also just be a kind of kindness, which isn't real common in the world right now. There's not a lot of love flowing out there.

Love has changed over the years, or my expectations of love have. I think I thought I knew a lot more about what love was when I was younger. I had a narrower definition of love. It was more selfish and self-centered. It was more problematic and dramatic. I feel less that way about love now. In a way, I'm more sure about what love isn't than what love is. And it's easier in a sort of way.

Pino Flores

I'm 100 percent Puerto Rican. I was born on the island, and I was fifteen years old when I moved to New York. I always knew I was gay, but I tried to hide it. I wasn't a happy gay person when I found out I was gay. It devastated me. I wanted to be like my brothers. I wanted to be very athletic and do the same things as they did. I wanted to get the praise they got from my father. I just went to the soft stuff: Boy Scouts, the saxophone in the school band. My father knew that I was different, so he was really hard on me, and he told me one day that I was his worst nightmare. And that's when I just decided that it was time for me to leave. I went to New York and lived with my mom's sister. I went to high school in Brooklyn.

I know what love is because I've experienced it. I loved someone and I was loved in return. That was my Jim. He was from Ohio, Polish and German descent, and he was tall, and he had the bluest eyes, intense; he was just smart. I mean, he was something else. He was in the Air Force. I know a lot of people that have been in the service and they're gay. But you know, they had to be careful. "Don't ask, don't tell." My friends, they said, "Pino, you're a very lucky guy. That guy only has eyes

continued >

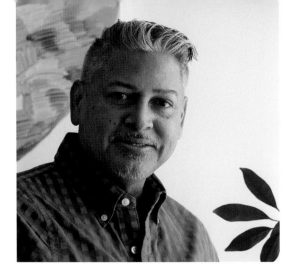

> > >

for you." We were solid. We were so comfortable with each other. Even if we had three-ways, he said, "I want to please you." He was so open to experiences.

I've had three main relationships and many encounters 'cause I was all over the place when I was young. I was very promiscuous until I met my lover.

I was working at the Cedars-Sinai Hospital, in the operating room as a technician. I had also worked at Neiman Marcus in Beverly Hills in the cosmetic department. I would get jobs, you know, [snaps fingers] like that, and it was easy for me to move around. But at Neiman Marcus, it was all about the right lipstick, minor stuff. At the hospital I saw life-and-death situations, and I was on a team that saved lives. We used to get the sickest of the sick. I got very lucky because I got promoted to OR coordinator in a very short time. So I would schedule the cases and the procedures and make sure that nothing was missing that they needed: surgical instruments, equipment, and supplies. It was very rewarding working in the hospital.

I did that in New York, and then I moved to Florida. It was very hard to find a job in that field, plus the pay was less than half of what I got in New York. So I became a massage therapist. I posted in a gay magazine, *The Hot Spot*, and I got jobs [snaps fingers] left and right. I'd gone to the school of oriental medicine in Los Angeles,

that's what I graduated from, massage therapist, and then I was licensed in Beverly Hills. I used to have my own clients, and I also used to work at the Beverly acupuncture center, as a massage therapist.

You know what made me laugh? When I look back and I see all the crazy things that I used to do when I was on drugs. I just laugh at myself. I can be there watching TV, and suddenly one of these images comes, "Why the world did I do that?" This is when I had recently moved from New York to Florida. I needed a job right away, so I started doing porn. It was in the late 1990s. I did two bisexual movies and one gay movie, and that was the end of it. That's not my type of lifestyle. You get to see what's on the other end. Easy money, the drugs. They have anything you want there. They have crystal meth, they have cocaine, they have pot, they have pills, you name it. Whatever you want we give it to you, we just want you to be yourself out there. Apparently I was good at it. They kept calling me, but I said "No thanks." It's something that I did to get some cash, but it wasn't for me.

I was diagnosed with HIV. It was 2004, 2005. And I will never forget it because it was on Valentine's Day that they gave me the news. The guy was so cold. He just told me, "Oh, you are HIV positive, but you have a nice day, today's Valentine's Day. Happy Valentine's Day." I walked out of the office, I walked to the train, and I saw the light of the train, and I said to myself,

"Should I jump?" I was so destroyed and dark. I remember I got home and I went to bed. I closed the curtains and I just totally isolated myself from the world. I did that for six months. And after that I said, "I need help. I need to get out of this black hole." I started going to therapy, and little by little I started improving my mental health. Then I started taking the pills, and little by little I was in treatment. The thing is that people say, "Oh, you can live a normal life." But in reality, you don't. You can't. Because there is something there that is sitting on top of you like a dark, gray cloud.

Life did change, and especially your sex life changes a lot. You have to disclose it when you're going to be with somebody. More than a few times I've met somebody and we get to the bedroom and we start caressing and then I say, "Listen, we're going to have to use protection." So then they say, "Let's watch a movie." "Where's my underwear?" A lot of them don't want to use protection. But I have a conscience. A lot of people don't have a conscience. But I have to tell them, "If you're fine with it, it's okay, it was meant to be. If you're not, it wasn't meant to be, you're not the right one, and forget it." But, let me tell you something. The first time hurt as bad as the last time because it's something you don't get used to. You don't ever get used to being rejected. You feel like you're damaged goods. So your life totally changes. To this day I've been with the disease for fourteen years.

Bonita (Bo) Best

I am who I am. I am me.

What I know about love is that it comes and goes. It's needed. It's conditional until it's unconditional. It takes inspiration. It requires creativity. You need to be selfless while keeping your eyes and ears open. What I know about family is that it can make, break, and shape you. It can do the unexpected. Biological, adopted, or chosen, family is for all.

I was able to earn my doctorate degree and have my favorite people be part of that milestone celebration. That gave me the greatest joy. Also, I finally pursued modeling after a decade, maybe even longer, of my daughter telling me to try it. Being able to travel and live abroad in Copenhagen, Denmark, was a long-term goal and a dream come true.

My advice to the younger generation is to follow your gut—you already know the answer. It's okay to be different and think differently. Find creative ways to pay for your education without accepting a loan. Live life without regrets.

Robert Croonquist

I was of that generation where you looked in a dictionary because you had heard the word *homosexual* and then you realized you weren't the only person who had these kinds of feelings. I grew up in the kind of middle-class prosperity that only rich people can have now.

I got out of there as fast as I could, right out of high school. I went to Stanford. I was there the fall of 1966. I was there for the Summer of Love, and I lived in Haight-Ashbury, and participated in the Vietnam War protests and the growth of the women's movement. I was a founding member of the first gay people's union at Stanford. It was a heady mix of psychedelics, Eastern religions, Native American religions, and leftist politics. The peace movement, and environmental movement, all of that. My sense of gay identity was formed in the idealism of the alternative movement. I was a hippie.

A few years after college I ended up living in a commune, 18th and Castro Street, with street transvestites from Boston. Those were the people I loved. Harvey Milk had the camera shop in the middle of the block. I met Harvey at the Ritch Street Baths, and we were, like, fuck buddies, but I loved him. He was really a great guy.

I would go up to Haight-Ashbury to the Winterland Ballroom every weekend and see Janis Joplin and Jefferson Airplane and Jimi Hendrix, The Who, and Joe Cocker, Aretha Franklin, and John Lee Hooker and Big Mama Thornton, all of those people. I wanted to be with the street people in San Francisco. I was at Monterey Pop, I was at Altamont, did acid, smoked a lot of pot. Never did cocaine or anything like that, because that was not a hippie drug. Or heroin.

My passion was social upheaval. It still is today. I had spent a lot of time in Mexico and got involved with liberation theology, so I was doing gay politics on Castro Street and anti-imperialist politics in Mexico. We were living on almost nothing. We would get odd jobs, and I had a small family stipend.

I moved up into a hippie commune in Northern California without electricity or running water. Lived up there for six years. They had bought forty acres of wilderness and given it to a progressive alternate school, and a hundred people moved up there. I got up there five years into it. I moved up with somebody who was living up there and who would stay at our commune when he was in town. We became lovers. And a bunch of other gay friends came up there.

At the same time, Harry Hay and Don Kilhefner held the first national gathering of Radical Faeries, and that became my identifier. I went to the second national conference. I became an intimate of Harry's and was close to him until his death.

I moved to New York. I came to visit a previous lover who'd moved to New York, and I never left. Got my teaching credential and taught for twenty years at Jamaica High School in Queens. I came here just as the AIDS epidemic was really taking root, so a lot of my friends in California died. A lot of my new friends were dying.

I feel in many ways the contemporary gay movement bought into just wanting to be like the heterosexual world. We were the ones who didn't have children, we were the ones who were the aunts and uncles who helped raise the children, who brought art and beauty and enriched them, and now we're the ones struggling to raise the children. I think something has been lost, and I think it's really sad. My generation is a voice in the wilderness I would like to not disappear. ▪▪▪

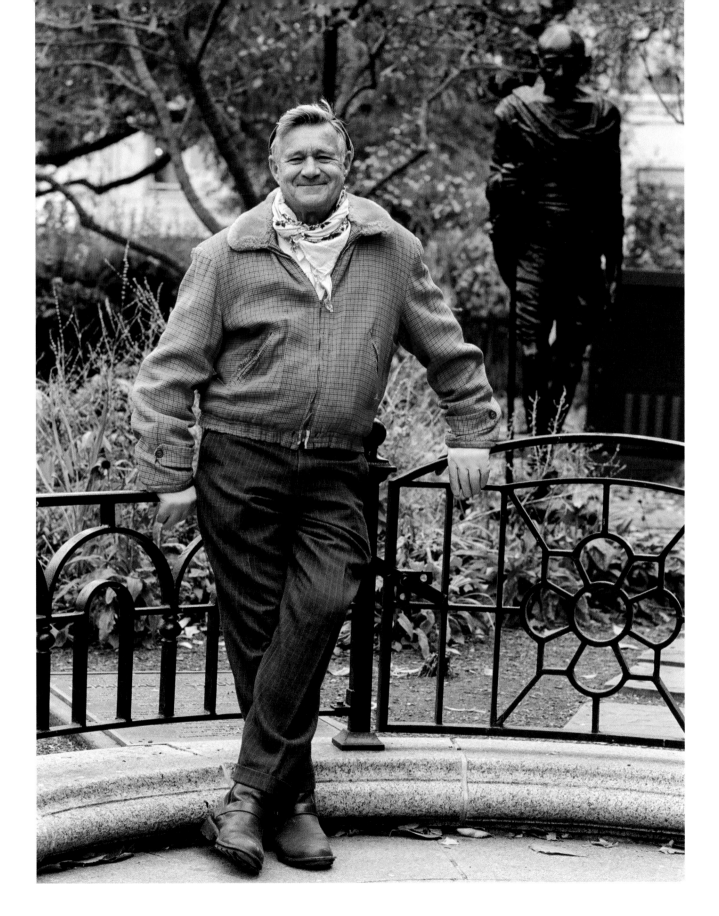

Steve Turtell

I grew up in Brooklyn. Went to a Catholic boarding school when I was thirteen because I was gay and it was the only exit that I saw that made sense. Two years later, I got kicked out for being gay after outing myself to Brother Superior. Got sent back to Brooklyn, finished high school in Brooklyn, then went to Brooklyn College, and halfway through my junior year at Brooklyn College I met my first boyfriend. I left home, and I went on the first gay pride march with him, and I joined the Gay Liberation Front.

I certainly did a lot of experimentation when I was a boy. You can get very confused when you're growing up and you have no models around you, and you have no idea until the eighth grade that you're not the only person in the world who's like you. During the eighth-grade sex talk our principal said, "And of course there will be some people who are homosexual, and they are attracted to people of their own sex." I didn't hear another word he said. I was up at the library that afternoon looking up everything I could find. This is 1964. What I could find was very scary. "You're diseased, you need to be cured, you're a pervert, you're going to be a criminal in all but one of the fifty states, you're not going to be drafted, you're just going to be a pariah for the rest of your life." And suddenly you realize that you're going to be rejected by your family, your church, your country, your culture.

My friendships are the foundation of my life. Romantic love comes and goes. Some people are lucky, some people are the marrying kind—so far I have not been. Love comes in many shapes and forms, and many different time frames and time spans, and for as long as you have it with whomever you have it, treasure it as much as you possibly can, because you have no idea what might happen next. There's one line in a poem by Auden that makes me weep like a baby: "I thought that love would last forever: I was wrong." It's work, yes, but it's worth every bit of the work.

There's never been a time in my life when I have not been in love. It's not always been with a person. It's been with an opera, it's been with a painting, it's been with a city, it's been with a mood, it's been with a song, it's been with a person, it's been with something. I can't remember a time when I have not been in love.

My friends bring me joy—watching them succeed, watching them be happy. Doing the same thing myself, feeling like I've made some kind of difference. There's a great quote from Martin Luther King Jr. that the arc of the moral universe is long but it bends toward justice, and I think I can say that in my lifetime I've watched it bend maybe an inch more, which doesn't seem like a whole lot, but it is a big deal. That's the only kind of progress we get. Things seem to stay the same, generation after generation, and in lots of ways they do, but there is change, and I've seen some of it in my lifetime. I grew up in the 1950s and 1960s. There were things that just seemed so rock solid and permanent: the USSR and the Roman Catholic Church, the two institutions that seemed like the most powerful institutions on the planet when I was a kid. I've seen things that I never thought I'd see in my lifetime. It never occurred to me to even think about getting married when I was a boy and knew that I was gay. That was the last thing on earth anyone would think about.

Debbie Millman

I'm a native New Yorker, and I was born in the 1960s. My parents got divorced when I was eight years old, which at the time was an unusual thing. I actually felt quite a lot of shame that it was happening, because people were blaming me, kids were teasing me that it was my fault. But I was somewhat relieved when they got divorced, because I was really afraid of my dad. He had quite a temper. I went back and forth between trying to please him and get his approval and trying to stay out of his way. After they got divorced, my mother ended up getting remarried very quickly. She was a serial monogamist. She was incapable of being on her own. The second husband was a bit of a monster, and emotionally, physically, and sexually abused me and one of his other daughters, and then emotionally and physically abused my brother and his other daughter. It was hard. My mother only knew later, much later,

not while it was happening. They got divorced when I was twelve or thirteen. Then my mother ended up having another boyfriend who was abusive, not with his hands, but with his eyes. He was a Peeping Tom. He would try to sneak pictures of me in the bathroom.

I took solace in school and I did really well. I did lots of extracurricular activities. I wanted to be away from the house as much as possible, so I was in the drama club, and the chorus, and student government. I liked and admired a lot of my teachers, and still am friends with people from high school.

Some of the best years of my life were in college, when I first came to understand I had talent, I was smart, and I was driven. I fell in love with the student newspaper. I wanted to do something with writing and design, and so when I graduated from college, I high-tailed it to Manhattan, where I've been ever since.

continued >

> > >

My first kiss was with a girl in third grade. We took turns being the boy and the girl. I was lying on top of her, kissing her, and then she was on top of me, kissing me. That was it. My second experience was in fourth or fifth grade. I went with a girl to the girls' bathroom, and we showed each other our private parts. It's interesting because I didn't know that there was such a thing as gay or straight at that point. I just assumed everybody was straight. I was never exposed to anybody that wasn't. This was in the early 1970s. It wasn't until I started to spend time in New York City with my dad, who despite the fact that he presented as straight, was working out at the McBurney YMCA three times a week. He took me to see *Chorus Line*, the first show I ever saw; lived in the West Village with his best friend, Harvey; and really loved Bette Midler. I have no proof at all that he was anything but sleeping with women, but there's a lot of interesting coincidences about his lifestyle. He also had a tremendous amount of anger, so it's possible that's why he was so angry. He came from an Orthodox Jewish family. Just breaking away from his religion created a lot of shame but who knows? I'll never know because he's no longer alive.

I didn't understand the concept of being gay until I was in college and I worked for the student newspaper. We were doing a special issue on LGBTQ people—well, at the time it was just lesbians and gays. I interviewed a gay woman, and suddenly I had this sort of sense that being gay was being home. I can't really explain it any better than that. I had a very deep—I wouldn't call it an epiphany, because it wasn't really an understanding of everything—it was an actual physical experience, this transformative sense of who I was without being able to say who I was. It was 1982. I had already felt so much shame about my body, about who I was, about sex. After everything I'd been through, I had a really complicated relationship with sex and violence. I had so much shame. It fucked me up on every level, and it took years to unravel and navigate and process.

At the time on Hudson Street there was an LGBT bookstore. I'd go there and read. I found the Ann Bannon novels, the pulp lesbian fiction that she'd written, and I'd buy them and read them under my covers with a flashlight. I would go to Cubby Hole. I'd go there and just watch. Occasionally I'd kiss a girl, but nothing more.

I was married twice to men. That didn't work out, obviously. And then, when I was fifty, I fell in love with a woman. At that point she was unwilling to be in a relationship with me unless I was out, and so I came out.

Now I am in a relationship with Roxane Gay. I pursued her. She was ambivalent about going out with me at first, and then she wasn't, and then we fell in love, and last October she asked me to marry her. I said yes and now we're engaged. I don't think you can really ever love somebody until you feel that you're worthy of love. I don't want to go as far as to say you have to love yourself, because I don't entirely know what that means.

I ran a brand consultancy for over twenty years. I started in graphic design, and then moved into branding, which incorporates graphic design but is a bit more expansive. I like making things. I'm happiest when I'm creating things. It could be a meal. It could be a piece of art. It could be a lesson plan. It could be a podcast. I started to develop the world's first graduate program in branding at the School of Visual Arts. I'm really proud of the work that we're doing with students. We're teaching them a way to create branding that's more focused on doing good as opposed to selling more soda.

People have asked me what has kept me going in the face of my various rejections and failures. What I can say is that my hope for something bigger was bigger than my shame. Hope propelled me. The desire for more propelled me. I think it was just in my DNA; I think I was born that way.

J

Jay W. Walker

My mother was a single mom. She had lived in New York and in Connecticut and Massachusetts, before she had me, and then I was born in Massachusetts and she brought me back to her home in Virginia to bring me up. The great thing about the fact that my mom had lived in New York and had traveled and had an interesting life before she had me was that we did not have a homophobic household. In fact, I was in part named after a friend of hers whom she had dated when she was much, much younger and who had proposed to her, and she had rejected his proposal because she knew he was gay and that he was trying to play the straight and narrow. She saw through it, and she was like, "No, you're gay. No, I'm not marrying you." But they remained friends, and when my mom chose a name for me, he was one of the people that was in her mind. And I met my first transgender person when I was fourteen. She, Alana, had been brought up a boy, grew into a man, realized that she was a woman, and went to work in the Saudi oil fields to make enough money to get her gender reassignment surgery. And then she became an interior decorator. My mom was an interior decorator, and she became Alana's mentor. She was beautiful. I still see her when I go home. So I was fortunate, as a gay person, to have a mom who just didn't look down at our communities, and that I had these sorts of folks in my life.

I came out to myself when I was maybe seventeen, eighteen, shortly before I went to NYU. And I started having sexual experiences with guys when I was at NYU. I didn't come out to my mother until I was twenty-five. And it wasn't because of fear of her judging me for being gay, but I moved to New York in 1985, so this was the height of the AIDS epidemic. And at one point, when I was about nineteen or twenty, I had a health

scare. It had nothing to do with HIV, but I went down to Virginia, and my mother had to nurse me back to health over the course of about a week while I was sick. I returned to New York, and two weeks later my mother had a stroke behind the wheel of a car and had a horrible accident. I just knew that it was from the stress of having to worry about her only child being sick. And so it was really hard for me to come out with her during the height of the AIDS epidemic, because I was really afraid that she would worry herself to death. So, it just took me a while.

Mothers always kind of know, I think. There's no girlfriend, there keeps being no girlfriend. Finally, the way that I came out was she asked me once when I was around twenty-one and I said no, and she asked me again when I was around twenty-five and I said yes. It was still an adjustment for her because as open and as perfectly fine with gay folks as she was, she was always concerned about my safety, my physical safety. By the time I came out to her, I was living with my partner. We had been together for about three or four years by that time, and we stayed together on and off for the next twelve years until he died. It was pancreatic cancer, but it was as a result of the HIV.

I would honestly say that activism brings me the greatest joy. It empowers you, it gives you a feeling of wider connection and of sort of communal, collective power, as well as the ability to know your own personal power, to be able to use your own voice and to be able to address issues that you have with whatever is going on in the world. ▬▬▬

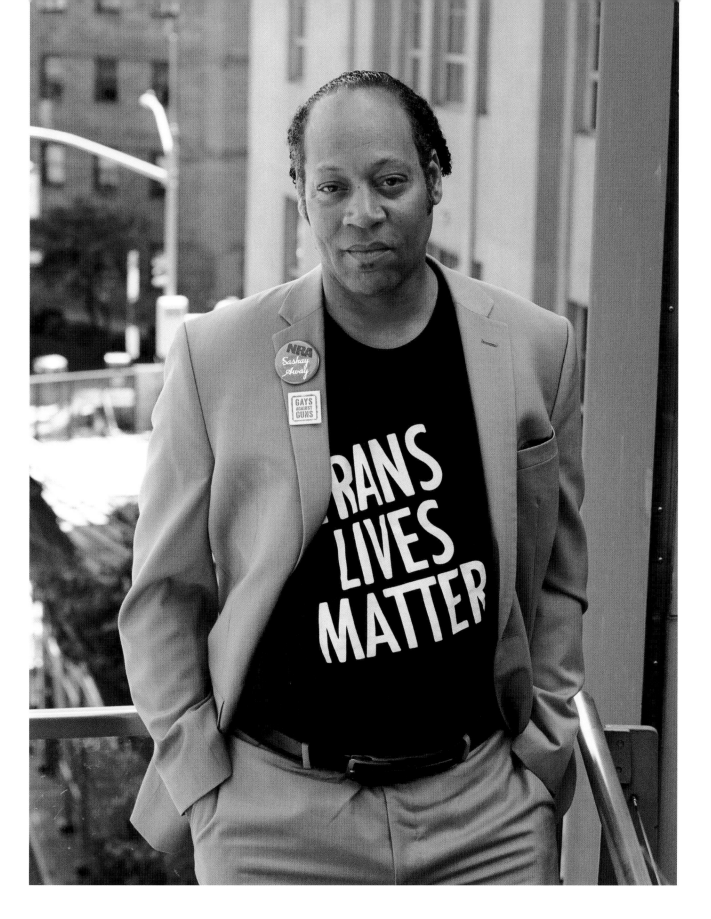

Richard Burns

I was born in New York City in 1955. I grew up in the suburbs and after high school went to school in upstate New York. I came out at Hamilton, as a sophomore, so it was probably 1975. It was a very conservative school, so there were not a lot of openly gay men. There were some open lesbians at the coordinate college, Kirkland College, but not a lot of guys who were openly gay. I think of that, in hindsight, as character formation. It was challenging. I was very lucky when I came out that I had a strong social network, basically from the choir. I was harassed at college, but not as much as I might have been.

I heard about a newspaper called the *Gay Community News*, which, at the time, was the only weekly lesbian and gay newspaper that was a serious newspaper in the United States. It was published out of Boston by a queer collective, and so I got the school library to subscribe so I could read it. And then I decided, well, I'm going to move to Boston and I'm going to join this collective.

So I started showing up at the paper and volunteering until it finally hired me, in 1978, and I ultimately became managing editor. It was a big collective with over a hundred members and about ten paid staff, and it was coed, which was unusual. It was feminist-identified, and it was very specifically pro-abortion rights. This was the era when Anita Bryant was running around the country encouraging anti-gay discrimination. And Harvey Milk would call up from San Francisco and yell at our news editor about a story. It was a very exciting time for a queer kid.

In 1978 we founded GLAD, the lesbian and gay legal organization in a church basement on Beacon Hill. I was lucky to have been able to come out and live as a young gay man before AIDS. In 1982 and 1983 everything changed. I was practicing law in Boston in 1985, and

I thought, "I can't just be practicing law, I have to do something." At the end of 1986, I came to New York to become the executive director of New York's LGBT community center. That year is when the New York City Council finally passed the Gay Rights Bill, a nondiscrimination bill, but it was also the moment when the U.S. Supreme Court issued the *Hardwick* decision, the case that upheld Georgia's sodomy law. The Supreme Court confirmed that it was okay for the police to go into a private home, into the bedroom, find two men in bed, and arrest them. At that time, well over half the states still had sodomy laws on the books. And we were three or four years into the AIDS epidemic, and people were dying everywhere. Ronald Reagan did not care, and [Ed] Koch gave the impression that he did not care. The spring of 1987 was when ACT UP was founded at the Lesbian and Gay Community Services Center.

For young people today, the years of the AIDS epidemic are ancient history. I can't expect them to understand or appreciate it. We can just tell the stories, and that's why I was one of the people in 2011 who founded the New York City AIDS Memorial. A portion of Walt Whitman's *Leaves of Grass* is carved into the stone: "Failing to fetch me at first keep encouraged, / Missing me one place search another, / I stop somewhere waiting for you." I can never read it aloud without starting to cry. That was our impetus in creating that memorial park, so that the younger generations will know that the AIDS epidemic happened and so that it provides a place for mourning, commemoration, and contemplation for people of my generation, for the folks from ACT UP, and caregivers, and survivors, but then be a monument to the activism that really changed a lot of healthcare in the United States, and an inspiration for future activism. ▬

Katherine Acey

I'm sixty-nine years old. I embrace my age, joyfully. It's a curiosity to me that I'm sixty-nine. I'm not sure what that's supposed to feel like. Thankfully, I have a lot of ability, mobility, physical ability, intellectual ability, although I am forgetting certain things.

I grew up in upstate New York, in a Maronite Christian family. Religion was very important. I learned a lot of good things and values around charity and hope and love, but as I grew up, I learned the church really wasn't supportive of all of who I was and the people I loved. But I'm what you would refer to as a lapsed Catholic. I do believe in spirituality, and I know that people have great faith, and I try to accept that. I can accept but also reject some of the major teachings, especially around women and issues around reproductive justice.

I have been an organizer and an activist since I was very young. I was a class officer and student body president throughout high school, college, grad school. I was very involved in trying to make things better, wherever I was. I was fueled by having very loving family, and some of the schooling that I got from the nuns. They were very big influences on me around kindness and compassion and justice.

continued >

> > >

My high school years were in the 1960s, so there was great turmoil in this country, just as there is today. There were the various uprisings, and it was the civil rights movement and the anti-war movement and the beginning of the women's movement. So there was a lot of political activity in the schools, but also on the streets. I come from a working-class family, so that just propelled me, guided by a sense of fairness.

I was just in Buffalo twice last month because one of my best friends, Deborah, passed away, very tragically, of cancer, and I still am crying every day. In college, we did a lot. I was not African American obviously, but my friend was, and we started black awareness on campus, because at this Catholic women's college, even though there was a significant black population in Buffalo, there were not many black students there. So we pushed the school to open up the doors a bit more widely.

I came to New York. My goal was to just finish graduate school. I went to Columbia to study social work—community organizing and planning. The idea was to go back to Buffalo. But I never left. I came in

1974, and I've been here ever since. I've only gone back to visit. And so being here in New York, I got involved in all kinds of movements, as I had been, and New York is where I became a feminist.

Women helped educate me to get me to really think. Until I came to New York, a lot of my schooling and social life was with women, and I didn't see sexism in the same way some others did. When I was in high school and college, I would hear from a distance about these women who were burning their bras. And that was mostly white middle-class women burning their bras. It wasn't until later that I learned that no, they didn't burn their bras. That was a whole myth. And they weren't white, although there was racism in the women's movement. Through women I met, I got involved in women's anti-violence activism and reproductive justice. There were these awakenings. I see them as awakenings, and it's like, how can you then turn back, once you become aware and exposed to these things?

In school, I knew I loved women, but I didn't think it had anything to do with my sexual orientation. Growing up in Utica, there were queer people. It was not an issue, but it was not an issue because it wasn't visible

and no one talked about it. New York is where I came out. I realized I was attracted to women, and it was like, "Oh my god, what am I going to do now?" But I moved ahead joyfully. And I came out. That was big. I had good people to support me on that journey, lesbians whom I could confide in. Coming out to friends and some family was exhausting. I remember going to Deborah. I must have been about thirty at that point, thirty-one. Deborah was very involved in the Baptist Church, and I used to go to church with her once in a while. I said, "You know Deborah, I gotta tell you something." So I told her, and she said, "I don't agree with this, but I love you and I'll always love you." And she just threw her arms around and hugged me, and it never became an issue.

I've always worked in nonprofits. I worked first at the North Star Fund and then at the Astraea Foundation in the early 1980s, which later became the Astraea Lesbian Foundation for Justice. I was there for twenty-three years as executive director, and for twenty-seven years, including my board experience. I'm still involved and supportive of them. Since I left Astraea, I've been at GRIOT.

Love, all kinds of love, whether it's friendship, romantic, sexual, or a love of life and of people, if one is unable to experience love, then it's a deep loss. I feel I'm very fortunate because I have felt deep love in my life and I have love in my life. My heart's been broken by lovers, friends, by the injustice I see and hear, from the children in cages to walking by all these homeless people. Those are heartbreaking to me. I don't like pain, but I'm grateful I can feel pain, because it tells me I'm alive and that I am a real human being and care.

I feel like I am very aware when I feel joy. There are many things that bring me joy. My sister lives next door to me, in a condo here in Brooklyn, and we share a big terrace garden. Looking out at those plants and trees, or sitting among them, brings me tremendous joy. I try to go out there and have my coffee in the morning, and just sit there and be peaceful. And I love to share that garden with people. I'm just always amazed because, as the fall comes and winter, everything just kind of dies, and you think, "Oh my god, they're gone." And then this miracle happens in April, May, and everything starts to come to life. And then all of a sudden here you are, and that brings me such joy to see this miracle just evolve in front of me. ▪

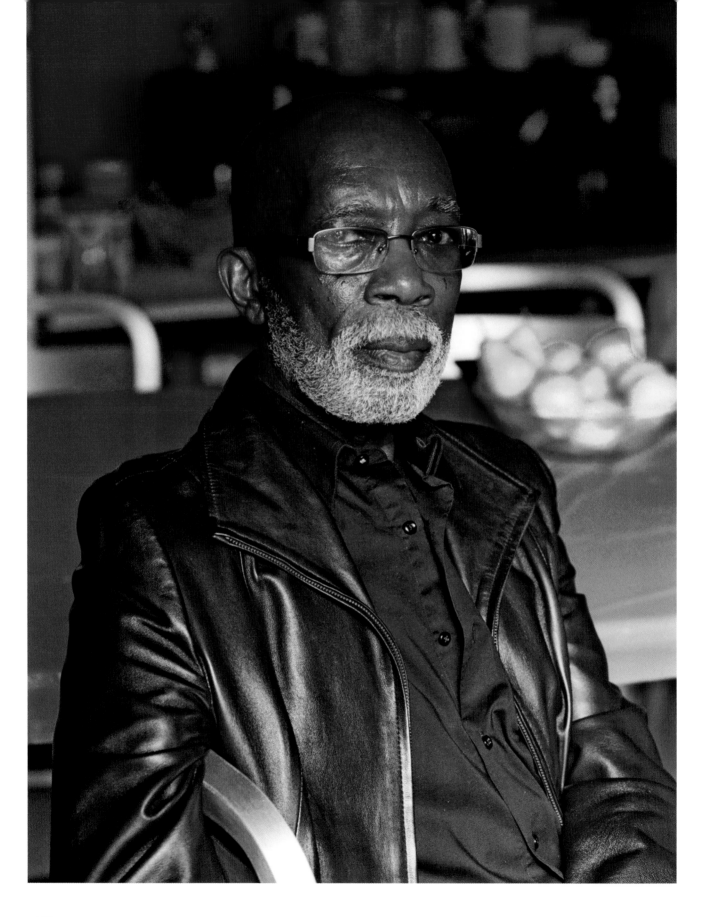

R
Robert Waldron

I've seen the upsides and the downsides of life. I have learned to take the good with the bad, the sweetness with the sorrow. Love is a wonderful thing. If you find the right person in your life to share life with, and enjoy life with, it's wonderful. Love flows according to the company you keep, the person you share your life with, the things you enjoy in life that make life worth living. I have been in a relationship going on thirty-eight years, and I'm enjoying the best period of my life right now. I get the love that I look for, that I can give back, and I'm happy.

I'm very emotional, and I try not to get in that emotional zone most of the time. I try to look for the little places and things, the flowers blooming, the bees, the birds chirping. I like sitting on a park bench, seeing the world go by. I get comfort out of certain things, I really do. I get joy out of life in general, and I see things, and I say, "Wow, I'm glad I'm still alive."

I was raised in a loving family who cares about me. I lived a sort of sheltered life, in a small community. I was an adopted child. I was not treated any different from my siblings. I was always pampered by my sisters. I was never left out of anything that the family wants to do. At the age of seventeen/eighteen, I started realizing I was really attracted to men. I think my mother knew I was gay.

I got to know my birth mother. I met my birth brothers and sisters. At the age of twenty-seven, I decided to leave Jamaica. At that time I did not know my birth father, so I looked for him, and I found him. I just wanted to know the person who was my real dad. We had a lovely conversation. We sat and we talked. I wasn't looking for anything; I wasn't looking for money, support, whatever. I didn't ask why he'd left Mom. I just wanted to look in his face.

I just moved on with my life, and I came to America. I got a job. I was working in the bank. I met a boyfriend. We stayed together for ten years. He became abusive. I didn't realize what abusiveness was. It wasn't beating up on me, but I had a lot of restrictions in life: I couldn't come and go, I couldn't keep friends. But I was supporting myself, so I said "No, I'm not going to stay in this relationship." I walked away from it. For a year and a half, I didn't date, because I needed to reshuffle the deck, and then I went to a party on Valentine's Day. How could I forget? I met this person. I was introduced to this person, my present partner. It's been amazing, it's been wonderful. It's someone I call my soulmate. We can talk about life, we can discuss things.

After meeting my present partner, I decided that I was going to get tested for HIV. It was about a year-plus we'd started dating. I get very emotional when I think about this. We were getting ready to go on a vacation, and three days before we went on vacation, I found out I was HIV positive. My whole world collapsed. It's like, how am I going to tell him? I went home, and I sat him down. I did not hesitate. Said, "Honey, I have something to share with you." And I told him I got tested and I'm HIV positive. I waited for the hammer to drop, and he looked at me, he got up and he came up and he hugged me, and said, "I'm gonna be here for you. I will be here for you." And he stood by me, and he's still standing by me. ▬

Kevin Uhrin Bill Self

Kevin *(left)*: I came from a very large, very macho, military family. I'm the baby of the family. There was never an issue with me being who I was. We never discussed being gay, or what being gay was. I was just different. I was very effeminate as a young boy, always very artistic, loved color. I was a clotheshorse, I liked things that other people normally would not wear.

I was the very first boy in eastern Pennsylvania to work in a cosmetic department. I remember my very first day in the cosmetic department. The store opens and this woman approaches, and I turn around and say, "Good morning, my name is Kevin, is there something I can help you with?" and she goes, "How disgusting." I say, "Excuse me?" She goes, "How disgusting, a man in the cosmetic department. It's okay for parts of New York or other places, but it's not okay for Scranton, Pennsylvania." I cross my arms and say, "You have two fucking options: you can take your sorry ass to JC Penney's and see what kind of service you'll get, or I can service you here. So, what will it be?" She says, "I'd like to speak to your manager." I say, "You're speaking to him, so what will it be?" She says, "Well, I guess you're going to have

continued >

> > >

to help me." I said, "Then what can I get for you?" And that launched my career. I ended up with a very well-to-do clientele in Scranton, Pennsylvania. I had five cosmetic lines, I had all the men's fragrances, I was making a salary, plus commission on all these lines, on top of getting a separate check after the store manager said, "Kevin, I'll give you a commission on anything else you sell in the store." I would come to New York and shop at Saks Fifth Avenue. It's when I got my exposure to New York. That's how I got to know the people in the cosmetic industries in New York. I would go back to work with red linen suits, or purple linen suits. I had men escorted out of the store with brass knuckles because I was so openly gay, but the store manager stood behind me and said, "Anybody ever touches you, Kevin, I'll put them through a plate glass window." Because I made them tons of money.

When I moved to New York, I lived in a basement apartment with two roommates that was three hundred dollars, and I launched my career. I've worked for Cartier, I've worked for Hermès, I've worked for Tom Ford, I've worked for Ralph Lauren. I've worked at Saks, Bergdorf, and Bloomingdales. I've been in that industry for a very long time. Now I have my own store here in Chelsea.

I've been very happy being who I am, and it's the way I was raised. My mother always said, "You are who you are, and no one can love you until you love yourself." And one of the things that I truly live by, what I truly live by, was my mother said, "Kevin, if you are gay, use the word *gay* to your advantage," and it's how I've lived. It's how I live my life.

Bill (right): My family is from northwestern Ohio. My father was in the military, so we moved all the time, until I was in junior high and then we settled in Corpus Christi, Texas. Education was always part of our upbringing. I think half of it was just because we were in the car all the time moving, and so my parents figured they'd stick a book in front of us and we'd be quiet. But also, my parents, they grew up in small towns during the Depression and saw education as your way out, no matter what you do. Then I went to university at University of Texas, at Austin, and I eventually went

to library school, deciding on librarianship rather than teaching because the last thing I needed to do was have a class of kids. I don't have that kind of patience. I worked at the university library, and then came to New York on vacation and saw things that I'd only read about or seen in books: the buildings, the Unicorn Tapestries, *Guernica* was still at MOMA, saw Patti LuPone in *Evita*. And I said, "You know what, I could live here, and it's time to move."

I moved in 1980. New York was tough; it was just still in the middle of the recession, and the bankruptcy, and everything. Still, I found it was very easy to be here. It was much more open. I lived in Hell's Kitchen, with the girls on the corner watching out for everybody. It's very interesting seeing how New York has changed, where every place is now upscale, as opposed to then. I was very lucky to get a job right away, with a consortia of medical libraries, so I started learning medical librarianship.

Kevin: We've been together for thirty-two years. I was working at Saks Fifth Avenue, and he was a customer.

It's all about the customer, all about the customer service.

We complement each other. We physically complement each other. He is one of the smartest people I have ever met in my entire life—he is brilliant, book smart, intelligent. I'm street smart. We both are very passionate in what we do in regards to our communities: not just the LGBTQI community, but communities in general, helping older people, helping youth understand there's a future out there for you.

We're very strong on making sure people are educated. One of the other things I have a big problem with when it comes to the younger LGBTQI communities, you don't know your history. You don't have the rights you have today because they were just given to you. People died for you to have those rights, so respect your older LGBT people, because we're still here, and we're still fighting. Get involved in your community. Your community isn't just going out, having drinks after work. The amount of people that turned out at this gay pride parade this year, I was overwhelmed. It really brought a tear to my eye to see the number of people that turned out. You saw a lot of families, you saw a lot of people, you saw every race, creed, color, size, shape, religion, all together. That's what a community is. So now let's take what we've seen and the fact that we had a great pride, and we had a great WorldPride, and we showed the world we are people, we do love, we do age, we do die, we do have rights. Let's take what happened and move it to something bigger and better. ▬

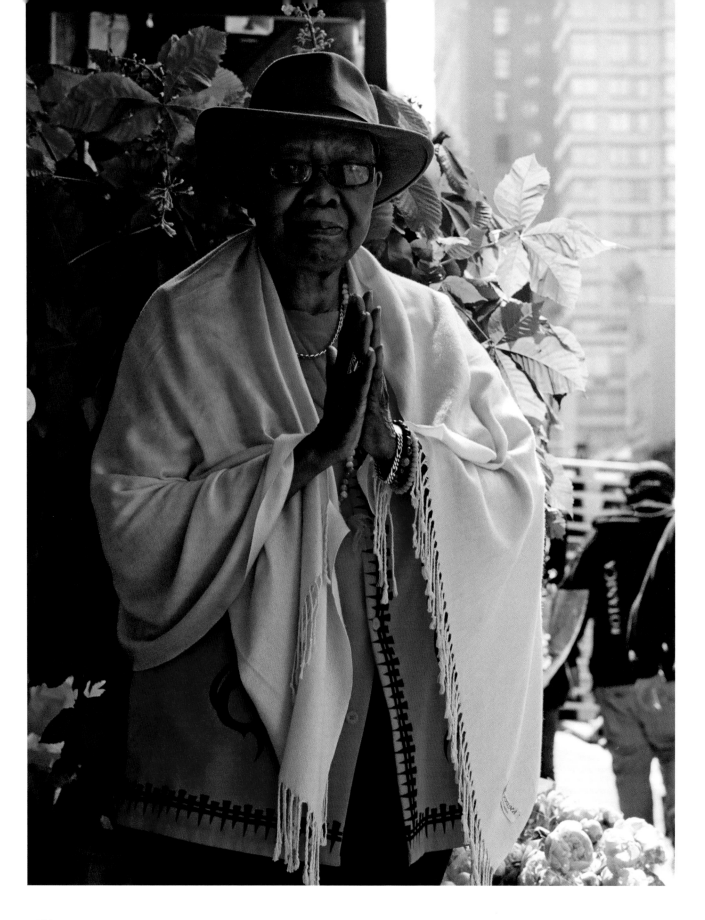

L

Lujira Cooper

I think that love is one of those things that we look for outside as opposed to inside, and if we're looking for it outside, we're expecting somebody to love us without us loving ourselves. Doesn't work.

I've always been a rebel. My parents were rebels. My mother and father were not married. My mother was the kind of person who trained me to not expect other people to give me things to make me happy. She and my father didn't get along. He was abusive. He was very abusive. I watched the arguments, and her telling him, "Get out. I don't need you. Get out." And him trying to buy my friendship. I think my mother loved me, and I think my father did love me, he was just a very complicated person. I know when he was in hospital, a couple months before he died, I wondered why he treated my mother the way he did, and he said to me, "Your mother wasn't always wrong." And I just smiled because I knew that's the best apology I was going to get from him about how he treated her.

I'm an alpha female. There's a lot of stuff I will just not tolerate. You will not do that to me, you will not say that to me. I've always been that way. I've realized, from all the relationships I've had, I have never been "in love" with anybody. I'm a writer, and I have two characters in one of my books, they are in love. I can see how they are in love. But I've never been in love the way they are in love. They're very honest with each other, they fight like crazy, but they're still very honest. They're attached. It's like when the universe made them, they were made for each other, and there's nobody else. I've never felt that. It came to me, "You've been with a lot of people—not that many—but it's the point that you realize that for what you write, you've never had it."

I remember I was in one of my English classes, and we had to write something, and I wrote an erotic scene, and I turned it in. My instructor said, "That's the best erotic scene I've ever read," because all I talked about is roller coasters, comets, diving into the ocean, the water. I gave a picture. We know what the sex act looks like, so the goal is, what was the energy, the feeling behind the act? And how did they feel afterward as they're lying there entangled in each other's arms as the light is shining down on them, or whatever [laughs]? It's funny because I have a friend who tried to write erotic literature, and I'm always telling her, "That's too graphic. We know what's going to happen once they're in the bedroom. I don't want to hear it again." We used to argue about this.

I think one of the problems we as older people have is that we're afraid to admit the fact we don't know something. We think we know everything. And as an older person you're supposed to have wisdom. However, having wisdom is being wise enough to know that you don't know something. My favorite line comes from the 1951 version of *A Christmas Carol*, when Scrooge wakes up and says, "I know nothing, but now I know I know nothing." It's my favorite line because it keeps me open to learning. ▪

Elizabeth Leifer

I came out the first time at fifteen, and my mom was like, "I don't know why you're lying to get attention." My father was like, "Why are you upsetting your mother?" Then it was like, "We'll never speak of this again." I didn't come out again until I was in my early twenties, and I had gotten married, had two children, and then was like, "I can't do this. I cannot fucking do this."

I think for a lot of people now, this up-and-coming generation, it's not going to be the same. In twenty years, they're not going to have to fight that hard against the system. There's actually a space, an allowance, for people to express themselves truly. What brings me the greatest joy is being able to give back to my community, being able to be an activist, being able to assist and help younger people who are struggling with some of the same things that I've struggled with. I've ended up being able to be sort of an example for younger queer people that come to work for me, who aren't sure what it's going to be like, and I'm like, "Just do your thing and let everybody else adjust to you."

My younger self, she just couldn't have imagined being this happy and this comfortable in her own skin. It's been a personal evolution. I've been masculine-presenting for quite a number of years, but if somebody had told me even ten years ago that I would be pushing fifty and was going to start taking testosterone and change my body composition and move forward in a space of being very nonbinary, I don't know that I would have believed it. And yet, here I am. What I know about love is, if you don't or can't love yourself, the love that you are going to end up giving to a partner is not going to be its most authentic. You have to authentically love yourself and who you are and find acceptance in who you are in order to be able to completely give that to other people.

I co-own a gender-equal underwear company called Play Out Underwear. I've been in fashion, marketing for a long time. For this company, our marketing structure goes against what the norm is. We put people of all different varieties on our site, we use them for advertising campaigns, we have volunteers who are in our community pride campaign. We help tell stories and help not just speak to our followers, but to our aspirational followers who are a little bit younger and may still be somewhere where they can't be their authentic selves, and we're trying to empower them and give them hope for their future too. These are people who are thriving, they have amazing jobs, they have amazing community, family, and friends, and they're living these amazing full lives, and they just happen to be queer as well.

Gender definitely is a social construct. It was created very purposely to make separation and division between individuals, and it's actually not necessary if you really boil it down.

It's interesting about people coming out or changing their gender later in life. There's just not that many people who wake up in their late forties and go, "Oh yeah, you know what?" For me, it was spawned by me having a double mastectomy for medical reasons. I was very clear on not wanting to have reconstruction, and it took me a year to convince my surgeon that that was okay. Because they really thought I was going to come back and change my mind and try to sue them or whatever, like she didn't want to do it. And I said, "No, I'm telling you. This doesn't define me as a person." It certainly doesn't define me as a woman. As soon as that happened, I had this surprising realization and everything sort of fell into place.

K

Kevin Scullin

I was raised in Southern California. I came out when I was sixteen. I mean, my first sexual experience with another person was when I was thirteen; it was with a neighbor boy. But I didn't quite accept the gayness. As a matter of fact, the idea of being gay scared me a little bit because back then, gays were marginal; they painted them, particularly in films, as somewhat sinister, or big screaming nellies. When I came out of the closet, I'd had a number of sexual experiences.

I had these two very effeminate friends who I went to high school with, who were very out. Tragically they both died of AIDS. I'm telling you, anybody over fifty, we've got the book that has the list of names. Anyway, I was ditching school and I was running around with these kids. We were all drama kids. My dad at one point, he confronted me. He said to me, "I'm not too sure about these queer friends of yours." And I said, "Well, they're not queer, they're gay, and they happen to be my friends." I went on, you know. And my dad's got this cigarette clenched in his mouth, and he looks at me, and he says, "Why, you thinking of going in that direction?" And that was the first time I ever thought

about it, really, and I remember I thought, "Yeah." It was kind of a "fuck you, you macho shithead bastard." He said, "Well, how long has this been going on?" And I said, "A while." And he said, "Your Uncle Dick didn't have anything to do with this, did he?" I'm thinking, "What's he talking about?" Well, I come to find out that my Aunt Betty, my father's sister, her husband would get drunk and have sex with men, and he kept getting caught. And so my aunt divorced him, and then he took up with—he ran a funeral home—the guy who did the flower arrangements. They became lifelong partners. I didn't realize that Uncle Dick was gay until my dad said that.

Two weeks later, they threw me out, and I lived on the streets of Los Angeles, in Hollywood, for most of my teens. I was sixteen years old, and they threw me out. By the time of my father's death, he and I had made peace. I had forgiven him, he had forgiven me.

I lived around. I was going to the clubs, the discos as they were called at the time, and I hung out with street kids. There were groups of young people, and

continued >

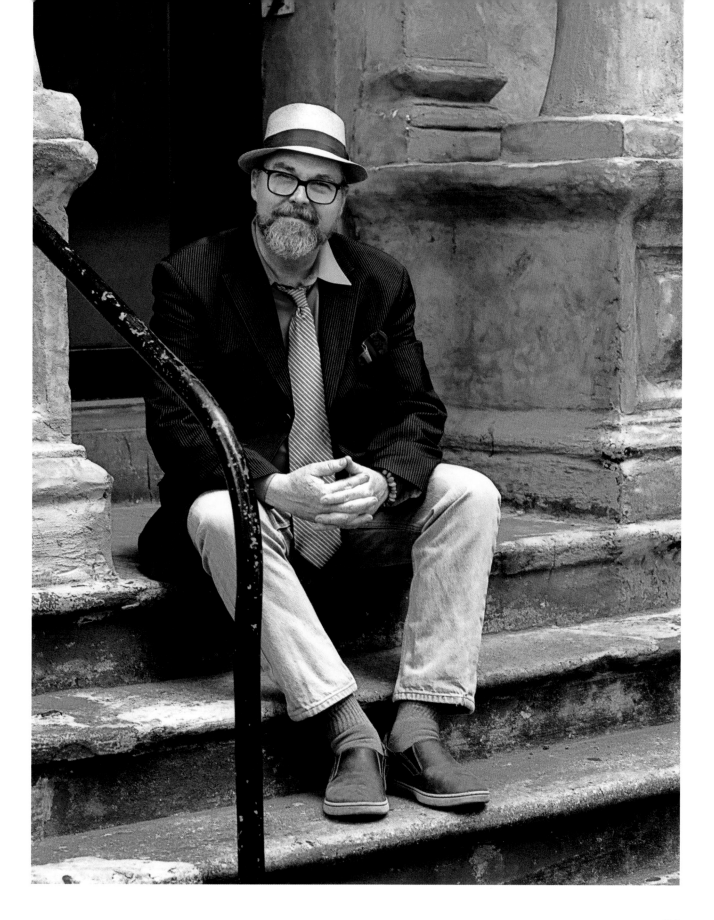

they would go out and they would hustle and make money and then everybody would pool their money and rent a room in a cheap motel, and that's where they lived. And everybody would sleep in the same bed. I kept thinking that, as a young person, that was how you were supposed to make a living, to prostitute yourself. I didn't know any different. But I was never any good at it. I couldn't just detach myself entirely to have sex with people. What I did, though, is I made the company of older men, who thought I was amusing and charming. They treated me nicely, and I thought, "No big deal, spend the night with them."

I also worked in a restaurant as a busboy, "a gay restaurant." I ended up meeting a lot of famous people, gay people. Back then there was this group of gay men who were very successful in show business. They were either managers or agents or producers, and so forth. What they used to do is they used to have parties. I had a friend who worked for a major record label, and so he used to say, "Oh, I'm going to go to one of these parties. Get about two or three of your best-looking friends." These older men would bring these men in their late teens or in their early twenties, and they would all

come, and basically these parties had all the drugs. And you would just go and get completely wasted, and hang and fool around with the other boys, and these wealthy gay men would be cutting deals and doing business, and occasionally one of them would say, "Oh, I really like that one over there." It was business and sex, and it was a secret.

As Blanche DuBois said, "I have always depended on the kindness of strangers." We looked after each other. A few of the kids I hung around with are still alive. But most of them have died. They died by drug overdose, or they died of AIDS eventually, or they were murdered. Life was a risk. Living on the street, you got by on your wits. The fact that I've survived the streets of Los Angeles, that I survived the AIDS epidemic, that I survived any of this, is sheer dumb luck.

I needed to get out of L.A. I had gotten down to, like, a hundred and nineteen pounds, and I looked sick because I was just doing so much speed and so forth. So I moved to San Francisco. I joined a kind of metaphysical church. Basically, it was is like a bunch of old strippers and drag queens and gay people who all got together and created a church that was accepting of

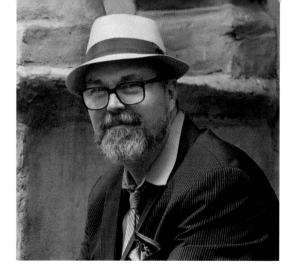

everybody. You could come with history and baggage and be welcomed. And I'm still very close friends with these people today, the ones that survived.

I got involved with theater, I started doing plays, I worked in a radio station, where I was a disc jockey, but my drug and alcohol abuse really increased. Like I was just knocking back the drinks and I was getting loaded a lot. I was sexually compulsive. I'd never really had a significant relationship, because I never trusted myself or other people in relationships, and I was always afraid that I was always going to get hurt somehow.

Eventually I moved to New York, in 1985, because there was a guy that I'd met who said, "Well, why don't you come and see New York?" and I worked as a bellman at the hotel. But I started to crash. I had just turned twenty-six. I was in a slow decline. I was like, "Oh god, I can't keep doing this." I didn't really think I was going to live past thirty. Shortly after that I got hired to work a catering job. The man who hired me and another man—I told them about the drinking and drugging—and one of them said to me, "Well, you know you don't have to do this anymore if you don't want to." He said, "Here. Here's an address. Meet me here at this address." And I went. It was an AA meeting. Coming up on July first I will be sober for thirty-three years.

That was the beginning of my coming into a self-awareness. I'm still a work in progress. I will forever be a work in progress until the day I die. What brings me joy now is, I love reading, I love listening to music. I love spending time with people that I love. I'm in a transition period right now. My heart is changing. It's changing right now, and it's changing for the better. ▬▬

K

Kim Watson

I came to the United States in my early twenties to study fashion. I wanted to go to school, and I ended up in social work, and now I'm the co-founder and vice president of Community Kinship Life, which is an organization that provides services for transgender and gender-nonconforming individuals.

My past is dark. I dealt with a lot of discrimination back in Barbados. I was born what in those days people would call a hermaphrodite, what we call intersex now. I was raised female, and I never had any difficulty with my direct family. They always let me live the life that I wanted. I started hormone treatment when I was eleven years old, and I started to transition when I was twelve years old. But it was not okay in Barbados. I had to deal with discrimination and name-calling. I used to be harassed a lot. Every day was a fight. It was difficult to hold onto my sanity.

When I got here, within thirty days I became homeless. Becoming homeless, and then doing survival sex and trying to make sure that I survived, I got caught up with drugs and incarceration. And then I said, "You know what? I want to live." I went into rehab and cleaned myself up. I decided that my life is much more precious than ever. A lot of people thought that I'd died from an overdose, but I was in rehab.

The AIDS Institute signed me up while I was in rehab and I started to tell my story. I was diagnosed with HIV and AIDS back in 1986, when everybody was supposed to die. With AZT, I am blessed to be here today. When I found out that I had HIV, I just wanted to learn more about it. It was an education not only for myself but for others. I started doing a lot of volunteering within agencies, for the AIDS Institute and the Department of Health, making sure that other people might not have to go through the same thing that I'm dealing with.

I'm working hard. There are so many things that I have to deal with right now, but I'm hoping for prosperity, I'm hoping for financial stability. I hope that one day things can change, because I would love to go back to school. Because folks are not going to hire me without an appropriate degree.

I was married for eleven years, and I just got divorced. I have a nine-year-old daughter. I adopted her when she was two months old. I adopted her without a name, so her name, her birth certificate, that comes from me. I also had a foster son, but his biological aunt came to get him.

My greatest joy is my daughter, my baby, my butterfly. She is so much fun. It doesn't matter if I'm upset, she puts a smile on my face. I love to hang out with her.

My advice to her and her generation is to always be open minded. Make your own choices. Don't let anybody choose for you. And pass no judgment on others. You're going to be okay. Continue pouring love, doesn't matter how much, always pour love, because blessings will come, and however they come, they will come to you.

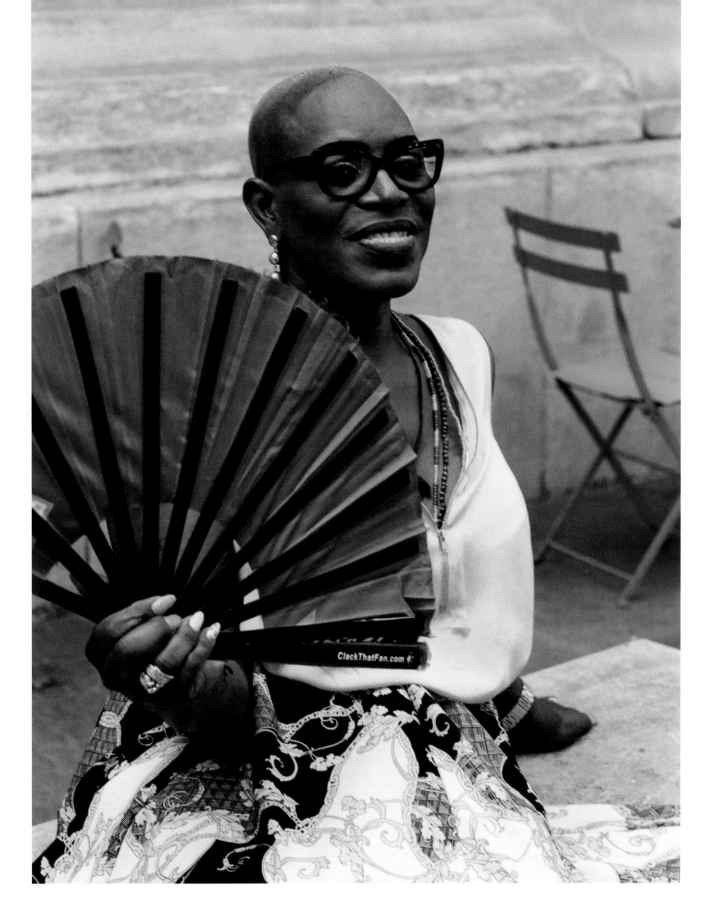

Stephen Honicki

My parents adopted me when I was six months old, and I was the first of three children that they adopted. I had a very uneventful childhood. I knew I was attracted to boys probably from when I was eight or nine, but I never dated a person until I was in my early twenties. I didn't know what I was waiting for. There was a part of me that was ready, but there was no guidebook back then. There wasn't the internet, there were maybe a few books in the library, but even those . . .

When I was in college, I met this guy. It was a friendship that was different than other friendships I'd had up to that point. It was very close. It was a lot of time just the two of us. We met at work—I had a part-time job when I was going through school—we would always go to lunch together, we would do things after work, we would hang out on a regular basis—to the point where other people perceived us as boyfriends. I remember one day I got up the courage to tell my friend that I was gay, and his response was, "Well, what do you want me to do about it?" He wasn't ready. We were in different places. We parted company for a bit, for a long bit. I found out later that he moved to Florida with an older man and they were living together down there. Later on, we reconnected, and my boyfriend at the time and his boyfriend, the four of us got together for dinner, which was a little strange, but it was good. And then a few years after that, we finally hashed things out. That was one of the few times in my life where I actually had a resolution to a relationship that ended or didn't go well.

I remember a friend of mine invited me to a birthday party, a surprise birthday party, and I inadvertently thought the person who the party was for was someone else, so it was a surprise for me too. Long story short, he was the person I had my first long-term relationship with. In hindsight, there were red flags from the start, but that lasted for seventeen years. It was dysfunctional,

and it became more dysfunctional after I got sober—I drank mainly to numb myself from the relationship I was in. Once I got sober, it was a transformation, a physical, emotional, and spiritual transformation. There were people that did not recognize me. That's when my work as a photographer began, shortly after I became sober. Before that I was a painter.

Finally, after I decided to call it a day, I was living for the first time, at forty-two, on my own. A lot of what kept me in the relationship was fear, the fear that I could not do it on my own—when the reality was I could. I always say my adult life began when I was forty-two.

Life is not linear. You're not supposed to be settled by a certain age, finish college by a certain age, have your dream job by a certain age, find the love of your life by a certain age. That doesn't happen. You have to figure it out on your own.

What brings me joy is doing something for someone else that typically they are not expecting and yet it's something that's done naturally, like, for me, mentoring a student, guiding a student to look at a certain artist or giving them the confidence to submit their work to a competition or festival. Or doing something for a stranger in a way that wasn't planned. Finding those moments when you can do that is the best thing. No matter how we come into the world or who raises us, we all have the ability to grow into the people we want to be, and make a positive difference in the lives of other people and the world.

Leslie Cagan

I grew up mostly in the Bronx. Both my parents were very engaged in community issues and the social change movements of their time. I grew up with an attitude of: you see a problem, you should try and change it, whether that's in the neighborhood, in the family, in the city, anywhere, at any level. Some of my earliest memories are of going to protest activities with my family.

It's been a life of organizing. I was the field director for David Dinkins's first mayoral campaign in 1989. A few years earlier, I was centrally involved in the organizing for the 1987 Lesbian Gay Rights March on Washington. In 1982 I was the coordinator of what up until the women's marches a few years ago was the single largest demonstration in U.S. history—the nuclear disarmament demonstration in New York. I've worked on a range of issues, the queer stuff, but also anti-war, a lot of foreign policy issues, but then also some very local issues, housing issues, and a fair amount on police issues, police brutality, police abuses, and a range of other things. I spent quite a few years just focusing on the women's movement.

continued >

> > >

Somebody quite a few years ago said, "Don't you feel like you're jumping around from issue to issue?" In some ways I could see how people might think that. But what I answered was that no, it's actually all the same. It's all part of the same struggle. It's not a single-issue fight, it's not about this community is more important than that community or this struggle has to take precedence over another. At any given moment in history, something emerges as the most urgent issue to pay attention to at that moment, and various community issues emerge, but in the long haul it's all connected. It's kind of simplistic to say none of us is free until all of us are free, but it's actually true.

Love, relationships, family, extended family, created family have always been an anchor for me and helped shape, and continue to shape, who I am. I've had a number of very intense, very important relationships. I came out in 1972. I spent a few years—*involved* is too much of a word—connected to men, and then came out. People come out in different ways at different times, often, you know, over the course of a life even. And they define it differently, at different moments. But for me the centerpiece of coming out was telling my mother. And she was great.

The last relationship I had was for twenty-one years. I had just turned fifty, she was about to be fifty-two, so it was for both of us a late-in-life relationship. We would say, "Oh, it's so terrible that we didn't meet earlier, we could have had all those years," and then we would realize, no, we each had to work through whatever had to be worked through so that when we connected it would work. She got very sick, and the reason why it was only twenty-one years is that she died. The dynamics and the reality of dealing with her sickness and knowing that the sickness was inevitably going to lead to death were just. . . . She was in very little physical pain, but the mental pain and just the amount of energy and effort that she put out to try and fight this disease was heroic, but it was a losing battle. There was no way she could win.

There still is a big hole in my life, a deep sadness, even though I'm laughing and experiencing joy and fun and pleasure with friends and loved ones. Some of the joy still comes from organizing. I was one of the core

people involved in this Queer Liberation March, which was the alternative to the Heritage of Pride March this year, because we still believe that the Heritage of Pride effort has become so dominated by corporations. Many of us are concerned that the gay movement, the queer movement, has settled on just being integrated into the structures of this culture that already exist. The real challenge is to break out of those boxes and to reimagine how human beings can interact with each other and not have it all be mediated through the culture of money.

Being engaged is extremely comforting to me. A lot of my work over the last several years has been in the climate movement. And to see the young people engaged in that work, being around young people, it's very hopeful. To be able to work shoulder to shoulder is joyful to me. I know I have things to share with people, just because I've lived longer and because of the experiences I've gone through, so I have things to teach them, and they want to learn.

I know for a lot of young people, between Trump and climate change and the up-and-down of the economy and the brutality of racism and misogyny and the violence and the culture of guns and everything else, the reality of the moment can be overwhelming. But I want to pass on to them that there have been moments in human history that people have lived through and survived with energy in very resourceful ways to get to a better place. At the same time, you can't just sit back and wait until things get better. You have to be engaged.

As horrible as things can be in the world, and even in your personal life, there are great joys and exciting things—and fun things—that happen. Just because things are bad doesn't mean you have to feel bad; you can still feel joy and pleasure. That sense of beauty and joy, I think many of us find it within ourselves, and for me it's much more meaningful when it's shared, when it's happening with other people. Sometimes that's one person, sometimes that's five, sometimes that's fifty. I could sit in a room and tell young people that, but I hope by being involved in different projects and activities with me, they see how I lead my life and maybe they can pull something out of that that helps them. That's a lot of what brings me joy now, that belief that for all of the problems that we face, there is always hope, there is joy, there is the possibility of positive change—and young people are stepping up. I'm not saying that I'm the perfect model and all the young people should be just like me. But they can pick and choose some things out of my experience that are useful to help them define and shape their own experience. In the end, I will hopefully have been part of the continuum where I learned from those who came before me. To me that's great, that's the future. ▬

Aundaray Guess

I grew up in Oklahoma City before moving to Minnesota. The teenage years were hard for me. I was struggling with my identity, struggling with what it meant to be black and what it meant to be gay. But the saving grace for me was my writing. I started writing poems. I don't know where that came from. Saving me was getting all that stuff out onto the page. Eventually that led me to start writing plays. I took an acting class in high school, and that's where I blossomed.

When I was seventeen, a little red Corvette happened. It was the 1980s, I would say 1984. There was this guy, he had a little red Corvette, and I would see him pass me when I was walking home from school. He was an older guy, maybe in his mid- to late twenties. One time—I think he timed it—I was crossing the street and he stopped right there and struck up a conversation with me. I was still so shy about my sexuality, but he started saying the right words, and he took me to this business he used to own, and that was my first time. I was scared. I didn't see him again until a few months later. He was about to rob a bank, and he threatened the arresting police officer that he had AIDS and he was going to bite him. The following year, I remember getting sick. I was like, "What's going on with me?" I'd never gotten sick before. I was about to graduate from high school. I think that was when I got HIV. Back then we didn't think black people got it, so I didn't think it was that.

I decided to join the U.S. Army Reserves when I was eighteen. That was the first year they were doing HIV testing. They tested me, and then they had me come back in. They said, "Something's wrong with our equipment." Maybe a month later I got a certified letter that had me come back in, and the conversation was this quick: they said, "You got AIDS, so we can't help you. And you can't join." That was it. I was eighteen and I was literally planning my funeral. At that time, AIDS was a death sentence. I had a nurse come to our house, and she showed me how to wipe, with bleach, the silverware, the toilet, so that I wouldn't pass on the virus to anybody. Because back then you didn't know.

I was waiting to die. My marker was Dick Clark's New Year's celebration. I figured that it was going to be my last time seeing it, but then I would make it, and I would see another Dick Clark special, and then I would see another. That's when I turned to writing again. That's when I really started fully embracing myself as a gay man, not the HIV-positive man.

I moved to New York in 2003. I wanted to get out of Minnesota. By that time I had found my partner. We both decided to just come to New York and start over. It was scary as hell. We had a little bit of money, but we had no jobs, we had no place. We found a place right away in Harlem. He found a job working with LGBT homeless youth. I also started finding my voice as an activist, working especially with young LGBT.

At the age of thirty-something I went back to school to get my bachelor's. I got my bachelor's at NYU, and I went for a master's, and in 2016 I walked out in Radio City Music Hall. This little boy who used to live in a Pinto, sleeping underneath the stars, learning he got HIV when he was eighteen, is now walking across the stage with a master's, so I was like, "Here I am!"

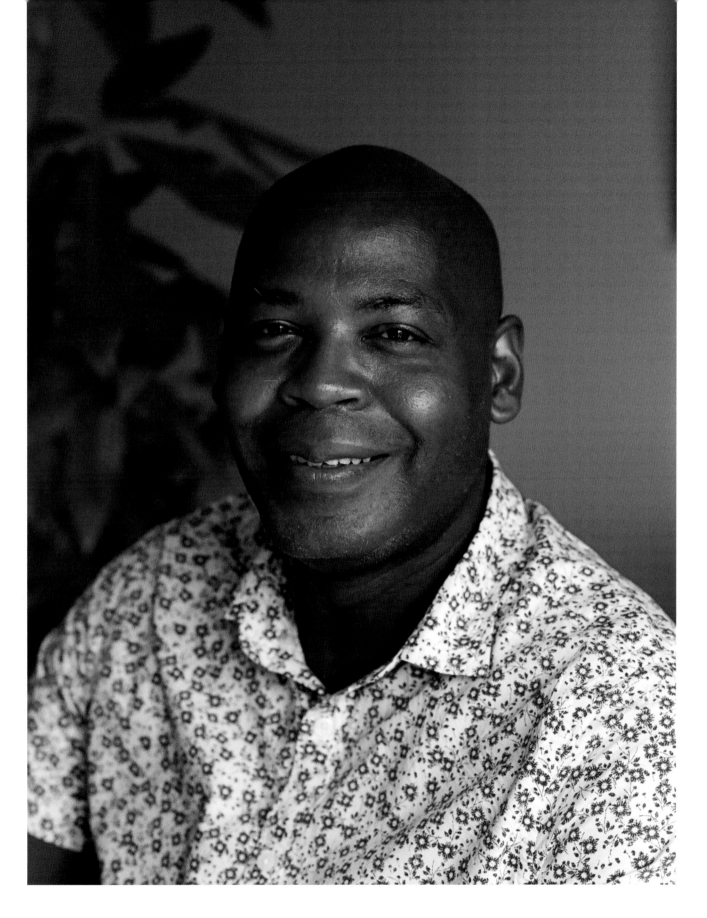

L

Lola Flash

My name has always been Lola. It's my paternal grandmother's name. And Flash, Grandmaster Flash is the inspiration. My last name was so normal, and Lola is so beautiful, I just felt like Lola needed something different, and of course as an African American our last names are controversial to say the least, so I never hung on to it as something that was mine. I loved my color theory class, in college, so for a little while I was Lola Violet, and then Grandmaster Flash music kept coming on, and I was like, "Lola Flash, that'll be good."

I grew up in Montclair, New Jersey. Montclair is Montclair, and then there's Upper Montclair. All the black people lived in Montclair, and all the white people lived in Upper Montclair. That's how it was in the 1960s. Until fourth grade we had segregated schools, and then in the mid-1960s they integrated our schools. I definitely grew up thinking that white people had money and black people didn't.

I came out kind of late. I knew when I was probably three or four that I wanted to wear what I would call masculine clothes now. And I told my mom, "Please don't make me wear dresses anymore." And she was so sweet, she was just like, "I'm sorry, I didn't realize that it caused you so much pain. You never have to wear dresses again." My dad would take me straight to the boys department, and I'd never have to rummage around in the girls department. I also remember going to high school and saying to my mom, "It's okay to look at girls, right?" And my mom was like, "That's fine. Women buy magazines because they look at other women's styles," so I thought that was fine. And then I just kind of kept looking at girls. I never realized that it was a sexual thing. It wasn't until I got to college that I actually had a relationship with a girl.

Mom gave me a camera when I was eight or nine, a little Minox. I remember always really looking and loving colors, and just always having this camera, but not really particularly knowing that I could actually make statements and help change the world with my work. When I was in high school, I would come over to New York all the time and tell my mom I was going to museums, and I'd end up in Washington Square Park. I walked around Christopher Street, looking, I guess, for myself, and not finding myself but seeing these cute, cute guys. I'm just enamored by gay men, I love the style of so many gay men. I definitely take a lot of my prompts from gay fashion.

After I graduated from college, I kept moving around. I got to New York around 1987, 1988, and before I knew it I was in ACT UP. My projects were shooting the demonstrations and stuff like that. It was a really tough time in all of our lives. So far as our community is concerned, love—and of course death—was what galvanized us as a unified voice, when I was in ACT UP. Love seemed like the simple solution to it all, but I can't see the LGBTQIA+ community advancing further without people loving each other a little bit more.

I never really wanted my work to be shown. I kind of wanted to be one of those artists who dies and they find all their work underneath their bed, because I never created the work for the attention of white-gallery goers. I wanted to show in pubs and restaurants so that regular folk could see the work, and then have those conversations. It was for the community, to photograph my people, to take my big old camera into their homes and make them feel like, "Lola Flash thinks I'm beautiful."

MS

Mark Erson Scott Jordan

Scott *(right)*: We met and fell in love in high school, in New Canaan, Connecticut.

Mark *(left)*: My family moved around quite a bit when I was growing up. We moved to New Canaan just in time for me to start high school. They had a wonderful theater department, and I just immersed myself in theater. Scott was a year younger than I was, and we did a play together, but we didn't get to know each other right off the bat. But then we were both in choir together, we connected with that. He stayed over at my house one night, and then he would stay over if my parents were gone for the weekend. I would drive him home, and we would park down the road from his house, make out in the car, and then I'd drop him off and go home.

Scott: The battery would die in the car.

Mark: We were sort of lucky. Many people in small towns grow up feeling so isolated, but we had each other, and we also had a couple of other friends. For the most part we were all in hiding. We kept it secret. But then there were like little slips. I remember when one of our friends was outed by accident by a friend who knew. I wasn't out at all. I always passed.

continued >

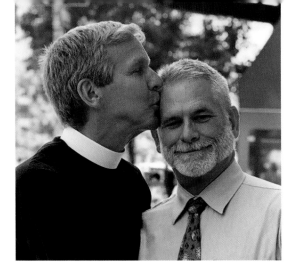

> > >

Scott: I was out and about. I passed for straight but I broke out. My guard was down, though, so I had more trouble after you went away to college.

Mark: In those years we all were telling ourselves it was a phase, and we would grow out of this kind of thing.

Scott: I never thought it was a phase.

Mark: I did. I kept hoping I could pray it away, so I'm thankful that the church I was a part of never chased me away. But anyway, then as adults we kind of came in and out of each other's lives. We were twenty. I went off to college. He joined the Navy for a while.

Scott: I was homeless, and I was using it to try and get off the street.

Mark: But then you almost married that woman.

Scott: I fell in with some rogue Christians in the Midwest who wanted to marry me off to their daughter. And that was when I had my first psychotic break. My dad and I would argue, and I'd say, "Dad, why would I choose to be like this? I see what happens to people like this. It's not what I would want." But then my rage turned to "Screw people. This is what I am."

Mark: I was in Minnesota, then in New York, and in Pennsylvania. He was back and forth between Provincetown and San Francisco . . .

Scott: It was before cell phones, it was before Facebook. I would have a phone number for him and I'd call it, and

it would be disconnected, and it's like, okay, we have to wait. We always knew we would find each other

Mark: And then we'd find each other . . .

Scott: And then it became a question of well, what about now? We always wanted to be together, but then it was like, "Well, not now, I'm with someone." One of us was ready and the other wasn't.

Mark: I waited a long time to go to seminary. I didn't start until I was forty-five, partially because of the church's policies: if you identified as gay you were expected to be celibate. And I knew that that wasn't for me. And so I was involved in the church as a layperson. But the church started moving toward changing those rules, and just ahead of that change I felt a new sense of calling. I'd felt a calling since I was a little kid but put it away. Then it kind of flamed up again, and I couldn't say no, so I went to seminary in 2005. We had dinner in the fall of 2006, my second year, and suddenly it was like, "Boom, this is the time." We'd been friends all this time, but this began the new phase of our relationship. That's another thing about love: It's about patience. Timing. If we had done this earlier, it would have imploded, and we would have missed out.

Scott: I was also sick and close to death for months, and then some new drugs came out and I was able to begin all of that, so there were a lot of things. It was a difficult situation.

Mark: But we both just felt it was the right time. We had learned the things we needed to learn from other people, in other relationships and stuff. Scott was in Provincetown at the time, I was here in Manhattan at school. He moved down in 2007, and then I served a church out in Queens Village for three years before being called to the church on Christopher Street. We got to St. John's just after marriage equality became a law of New York State in 2011, and so we got married in November of 2011, at the church that I'm serving.

There is diversity in love, and relationships, and the idea that there is one cookie-cutter version of a committed relationship is outdated. And always has been. Diversity has always been there, it's just now people are talking more freely. When people question the validity of a love between two men, I can honestly say that I see and have experienced a deeper sense of the love of God through my relationship with Scott. I see it as a divine gift, and it does not take me away from God; it actually draws me closer to God. And so I think that anything that draws us closer to God is sacred. And so this love that we share is sacred in my eyes. And the love that we share, the relationship we share, he makes me a better pastor. This love only enriches my life.

Scott: I argued once with someone who said love is an energy and not a feeling, but I understand that now. You can say "I love you" over and over and over, but for me it shows up in service, in compassion, and understanding. The value of love in relationships is the same everywhere. It doesn't matter what your race, creed, whatever. I love that love is love. It takes effort. I had this idea that "oh, fireworks, we're in love," and I've seen so many relationships end when the romantic love or the physical love wears off, and for me it doesn't. It takes effort. And yet at the same time I also find whatever energy I put into it, I get back two-fold, so there's a great motivation for doing that.

Mark: I think the hardest thing I've ever noticed with gay men is their difficulty with intimacy: if I let my guard down they'll find out what I'm really like. There's so much self-hatred put on us by society. It takes courage to make that leap or hurt someone's feelings to try to get an answer. It's about being courageous. You have to be honest and have trust. And it's just amazing to develop that.

Scott: I think that's why we're so lucky.

Mark: And as well as we knew each other, there was still so much to discover.

Scott: I never thought I'd have the kind of inner peace I have now. I'm fortunate to love a lot of members of my blood family, but at the same time I look at the people in my life, and the people I love the most are the people who are there to say, take care of you first, because what it says is we value you.

Cindy Rizzo

I know that love is probably just about the most important thing that you can have in your life, because I think everything else kind of falls into place if you have it. For me, what I've noticed over the years is that people who grew up with what I would call unconditional love in their families, where, no matter what happened, their parents loved them and cared about them, those are the people who I think are the most confident and well-adjusted and successful, not so much in a career sense but in a relationship sense. I was lucky enough to have that kind of unconditional love from my parents, and so it's really important to me to show that to the people I love in the world. No matter what, the love is still there. It doesn't have to come from a partner or a spouse; it could come from your close friends. A lot of LGBT people create families of choice, sometimes because they don't have their biological families, and sometimes because that's just how their lives have evolved. I think that the love you get, no matter the source, is really important.

So much happens because the young do something. The Stonewall rebellion happened because young people fought back. There's so many people who were young when they did amazing things, and even if they didn't do amazing things, their dissatisfaction with the status quo was what made things change, whether it was being against a war, or fighting for different kinds of rights, or making sure that people who were never afforded any opportunity had an opportunity, or calling attention to violence against young black men. Young people have a lot to offer, and I would just tell them to do what they can to make a difference in whatever area they feel they're competent to do so. It doesn't have to be political or movement oriented. It could be writing a great book. But keep pushing at the margins, keep being edgy. Create room for people by doing that. And then, try to hold multiple truths. Understand that the world isn't so black and white. Things are not so either-or. Don't be so self-righteous about things. More than one thing can be true at a time. It doesn't mean I don't have my own values and perspectives and opinions on things—I certainly do. It doesn't mean that if somebody's homophobic and somebody's not, both views are valid. What I'm saying is that there are many pathways to justice, and sometimes you have to understand that people have different points of view about that. There are times you have to understand things that appear to be opposites are okay to coexist, and it doesn't mean that you don't fight hard for what you believe is right or to uncover injustices. I think it's a hard balance to reach. I really hope that young people can have some insights into how to do that while still remaining out there and pushing back. I have a lot to learn from them, and they have a lot to learn from me. We don't want to lose any of our history or the wisdom of people who are older. It's a two-way street. ▬

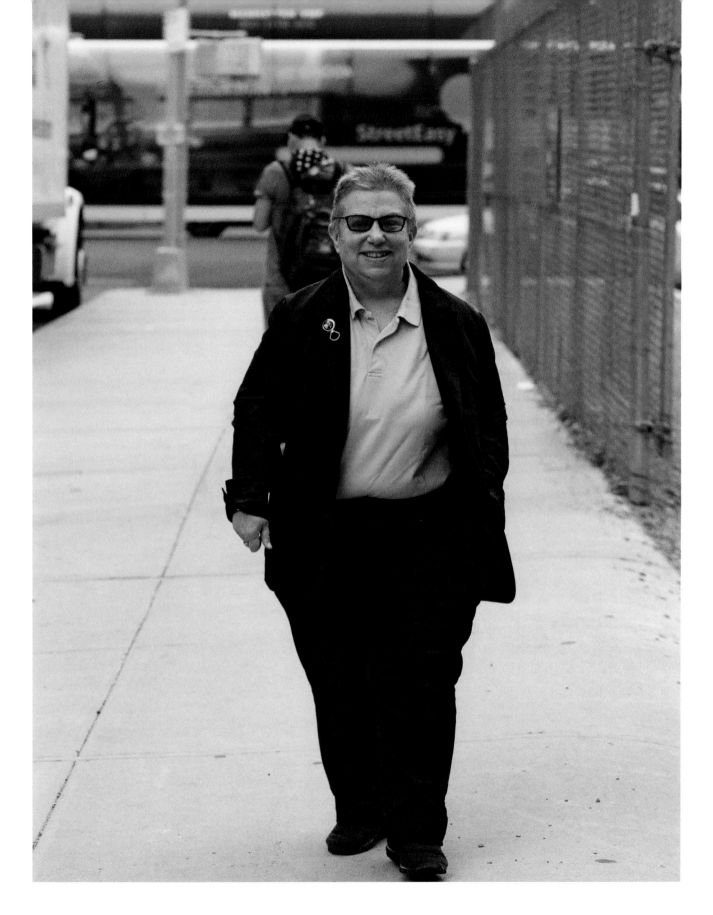

Reginald T. Brown

I grew up in Kansas City. It was very conservative and very white. Every educational institution I attended was predominantly white from grade school all the way up to post graduate. I was an overachiever, and I excelled in everything. I grew up in the first black subdivision built in Kansas City. It was a fairly stable middle-class neighborhood. I would walk to school and walk home and go home for lunch. One day, on the way to school, about five or six boys surrounded me. I was absolutely terrified. They started teasing me, calling me faggot, and punk, and sissy. I didn't know what these words meant, but I knew from the look in their eyes and the tone of their voices it probably had something to do with the fact that I was attracted to men. I was about eight years old.

The teasing hurt. I would rather they hit me. If they had hit me, I'd forget about that. That whole thing about sticks and stones may break your bones but words will never hurt me, is a lie. I can remember the first time somebody called me a faggot. I can remember the first time somebody called me nigger.

Fast forward to 1971: I was a freshman at the University of Kansas. It was my first time away from home, and I was glad to be away from the bullying. I was ready to look for all these sissies and punks. So, I cruised the john, I met a man, an older man, a graduate student from San Francisco. We hooked up. He told me about poppers, weed, and dildos. He took me to my first Gay Liberation Front meeting. I walked in that room, and that was the first time that I saw a room full of proud queer people, and I thought, "Wow,

I'm actually in a room of people where I don't have to be anything else." I can actually be myself and not be afraid. That felt so good.

We decided that we needed a place to meet on campus, so we applied for funding from the university. We were denied, so we sued the university, and William Kunstler, the famed civil rights lawyer, took our case pro bono. It was at this time that I decided to come out to my mother. I wanted her to hear it from me because I knew that my name was going to be associated with the lawsuit. She looked at me and smiled and said, "Well, Reginald, I always kind of thought so, but I never taught you who to love, I just taught you to love. And no matter who you are and what you do, you will always be my son, and I will always love you." When I heard that I thought, "Hell, I can take on the whole world." And we did.

We lost the appeal, so we had to change tactics. We formed a speaker's bureau. We ran around to various universities to do teach-ins. The first school that we went to, when I walked into that room, I saw three of the boys who had once terrified me. I was able to walk over to them, look them in the eye, and say, "Yes, this is who I am, and I'm here to teach you." That was an epiphany for me, that was my coming into myself. I wasn't going to take that shit from anybody else ever.

I was diagnosed HIV positive in 1986. The diagnosis was pretty much certain death. That'll be thirty-three years ago, and I've not had one AIDS-related illness. I've been undetectable, unable to transmit the virus since 2003. My purpose is to be visible, to share my story, and I'm glad that I'm still here to be able to tell my story.

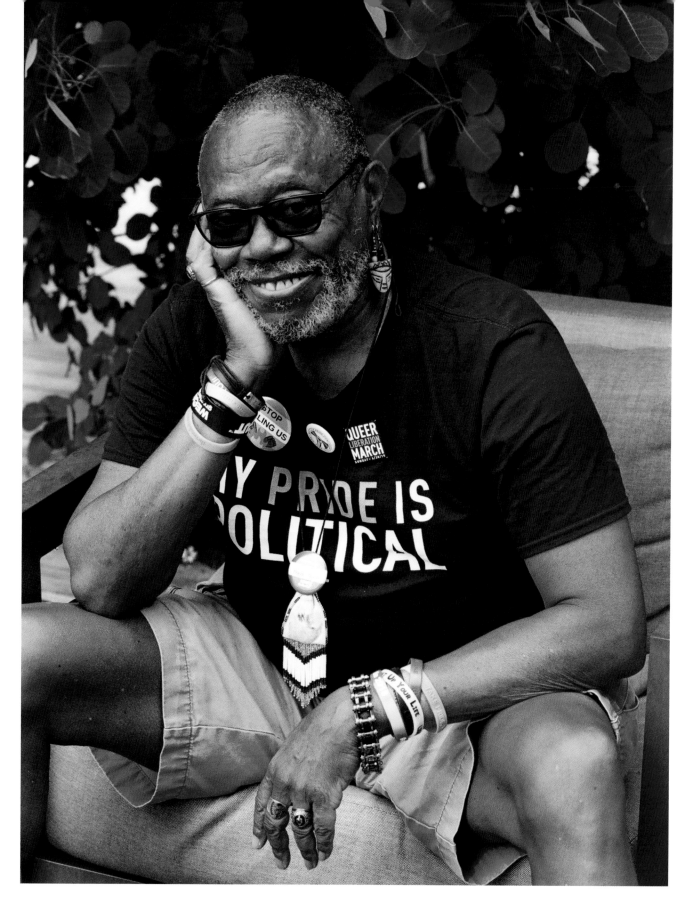

Paul Vitagliano

I grew up in a suburb of Boston called North Quincy. I was the youngest of four kids. My parents got divorced when I was seven. My dad was cheating with his secretary, so my mom kicked him out. In those days, you didn't do family counseling. It was like, if your spouse is cheating on you and you're Catholic and you're Italian, it's just like, "Get out!" So, I didn't know my father. After he left, he only saw me maybe five, ten times, and then he disappeared. He just didn't really care.

My mom had to go to work, so I was left alone a lot or at neighbors' homes because I would have to go to their places after school and stuff. I escaped into drawing and art. And that was my favorite thing to do. I was always a very creative kid. I got good grades, and I wasn't a problem, but I was a little hellish. I was rebellious. I knew I was gay, but I didn't really know the word for it, and I didn't think there were any other people like me. And it's not like my mom ever talked to me about anything.

When you grow up being gay, you carry this sense of "I'm the other," and you realize your experience is going to be totally different from all your friends' and all your peers'. At least, at the time, you don't think any of them are gay as well. You're carrying a secret, you're carrying this burden of "Oh my God, if someone finds out." The guilt, the shame, all that shit, it's what society has assigned to how you feel.

I finished high school, and my mom was adamant that I go to college. I went to UMass Boston. But in the summer between high school and college, there was a radio station that I loved that wanted to find people to answer the request line. So I applied and I got it, and about eight months after that, the station partnered with a dance club, and they needed a Monday night DJ, and they said, "Do you want to do it?" I said, "Okay. Sure, I'll give it a try." And that's how my DJ career started, and I've been doing it ever since, since 1981, when I was nineteen. And I worked my way up to some really great clubs.

continued >

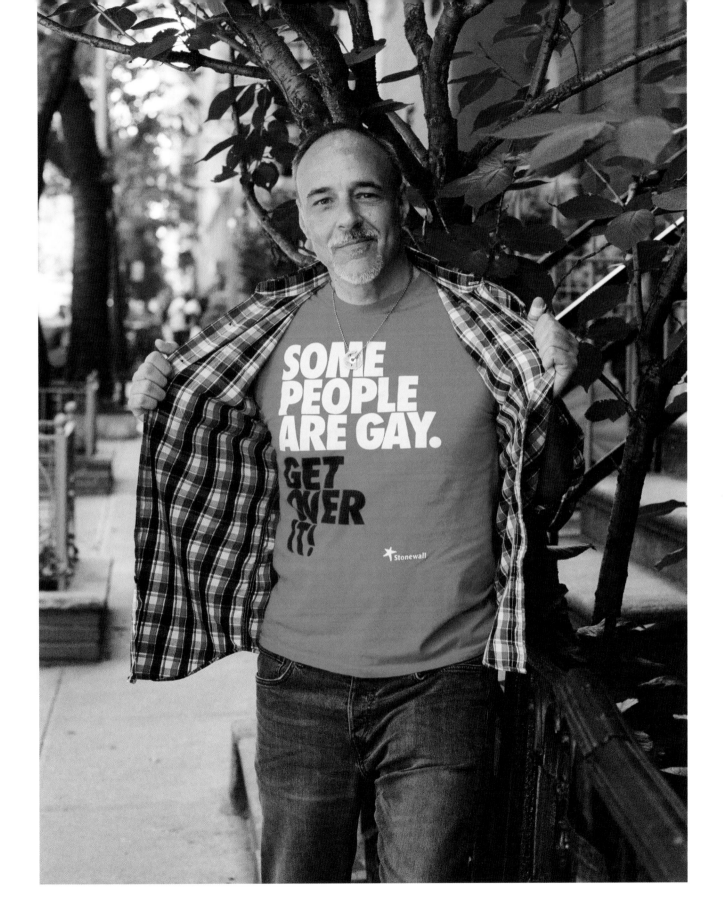

> > >

I got to know a woman that worked at Warner Bros. Records in Los Angeles, and they needed to hire somebody to promote alternative music to college radio. Back then it would have been like the Talking Heads, Depeche Mode, Echo and the Bunnymen, New Order, REM. They hired me, and they moved me to Los Angeles. An incredible opportunity, a once-in-a-lifetime. That's how I got to Los Angeles, and then I continued to DJ while I had this job and ended up doing my own events, as the promoter and the DJ.

I did a club for twenty years called Dragstrip 66, which was a monthly themed alternative drag masquerade dress-up. The crowd would get the theme a month ahead of time and show up in drag for the theme of the show. But we would put on the show, live singing, no lip-synching. We had a whole stable of drag queens that would sing. At the time, drag was very underground, and it was not welcomed the way it is now. But back then it was very much like this club is gay men cruising and dancing and we don't want drag queens because that's not masculine and we are masculine. It was more about shame. That was still a time when everyone assumed that all gay men wore women's clothes and did drag. Like if you were thought of that way, you weren't masculine, thus you were less powerful, or less . . . being masculine was a big deal.

Anyway, the club was a huge success, really broke down a lot of that bullshit, you know. We welcomed everybody, and everybody felt welcome. Even if you don't want to dress up, you don't have to. You can come in jeans and a T-shirt. But when you're there, you have to let go of some of that baggage and that bullshit that you carry, and you have to add something to this party because the people make the party. We were underground, we were, it was all word-of-mouth, we didn't advertise it. So, if you didn't hear about it from a friend, you probably didn't know we existed. And so, the right people found it. And the right people kept coming back when they got it.

It's probably the thing I'm most proud of because it created such an amazing community of friends. It was so friendly; people who met there as complete strangers just struck up a conversation on the patio, on the dance floor, and they are BFFs now, twenty years

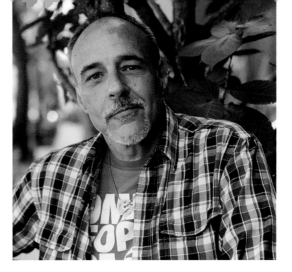

later. So, all these great connections happened. And we really connected people that should know each other. My pride about it was that it was a great community marker for the kind of left-of-center part of the gay community. And the fact that nightlife is fleeting, and popularity is really fleeting, and the club was packed and crowded and the place to go for twenty years.

I'm a firm believer, especially in the gay community, that every generation stands on the shoulders of the generation before. And each decade, as it gets better and gets more accepting for the LGBTQ community, we really have to honor who came before us. I try to do my part where I can impart what I've learned or what I know through my experience to someone half my age, even though, it's funny, a twenty-five-year-old doesn't care what a fifty-seven-year-old knows. And it's like, "I know a lot about you because not very long ago, I was you." I want them to understand that the reason they can get married now and that they can be in the armed services, not that I support that, the reason they can walk down the street holding hands and can kiss in public—there were a lot of battles and blood, sweat and tears, and death. People died. It was a war. And people died. Not just of AIDS, but people got killed or beaten to death or whatever. That makes it possible for what we have now, which is this really incredible daily blossoming and expression. So, I feel that especially for my generation, if we did make it through, it's really our duty to educate and connect with younger people and make sure they know our history.

Evelyn Whitaker

Sonja (right): I was born in Barbados. I came to the country at age nine. My mother was an American citizen, and we were with our grandmom, in Barbados, and my mother wanted us to come to the States to be with her. I basically grew up in New York, in Bed-Stuy and Flatbush.
Evelyn (left): I was born right here in New York.
Sonja: Love is a precious gift. I was very fortunate. I met a wonderful woman in Evelyn, and I couldn't be happier. I worked for CUNY. I was on the faculty there. I was fortunate enough to move up the ladder, so I was an academic dean, working with faculty and developing new programs. Started a center for teaching and learning. Met Evelyn there. I worked for her, actually, at one point. We did a joint project together, the student development center. Then we started doing presentations all over and traveling together. It all started with the traveling together.

It was a difficult decision because I was married for twenty-odd years and I had two sons. I didn't get a lot

of flak from my sons. I'm sure it was difficult for them, although they were young men then, not kids. My mom, she was amazing, because I didn't hide my sexuality from her, and when I left my marriage, she never said one negative thing.

I met my husband in school. We got married soon after college. We were married for over twenty years. The reason I began to have issues with him is that we did not grow at the same rate. We simply did not have the same ambitions. He was a great guy, had a good profession—he was a physical therapist, had his own practice—but he got consumed in gambling. It was an addiction. That's when I decided to call it quits.
Evelyn: I got married while I was in college. My son was born in 1957 while my husband and I were in Germany. He was born with a rare neuromuscular condition, and my son and I were sent home from Germany for diagnosis and treatment of our son. My husband, who was in the service, returned to the States shortly thereafter

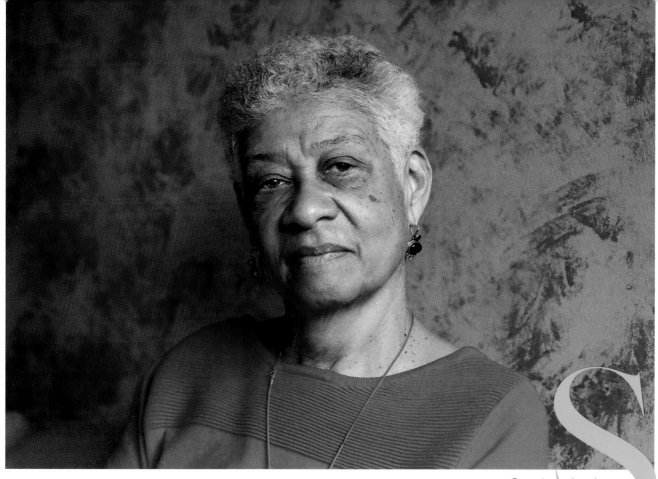

Sonja Jackson

and returned to college to obtain his bachelor's degree. He also worked nights to care for us financially. He had very little time at home for us.

My son was four years old when I left my marriage. It was not difficult. I had started working when my son was two years old. It was on the job that I met the woman who became my partner. She was eight years older than me, and attending college two nights a week to obtain her master's degree. She came home with me before class to help with my son, who required a great deal of care and attention. I also needed "a mother" to care for me. She was the right person. She took care and nurtured both of us.

On the job my supervisor was a role model for me. In addition to being a good supervisor, she was also gay and professionally competent and made it easy for me to acknowledge and accept my feelings toward my new-found friend, who I wanted to be with, and to move on.

People have always said I was strong. "She's a strong person, she is not going to let anything stop her if it's something she wants to do." That was true to a certain extent. It took a great deal of guts and strength to leave my marriage for a woman, especially with a sick child. It was scary.

Love is the most wonderful feeling, there's nothing like it, because it just takes over my whole body when I feel it. I'm not talking about sex. I still experience the warmth and completeness of being loved with my current partner, Sonja. With her I feel so loved. I am truly blessed.

I also love dancing. When I'm dancing I'm just so jubilant, you know. I don't do it a lot now because I'm having arthritic problems. I can still move my body, but it's just not as easy. I am eighty-three and a half, and proud that I can be here and still active. People say to me, "Oh, she's an active one, so don't expect her not to be on the move." It's something that I cherish and that I keep doing. I'm on the move. ▬

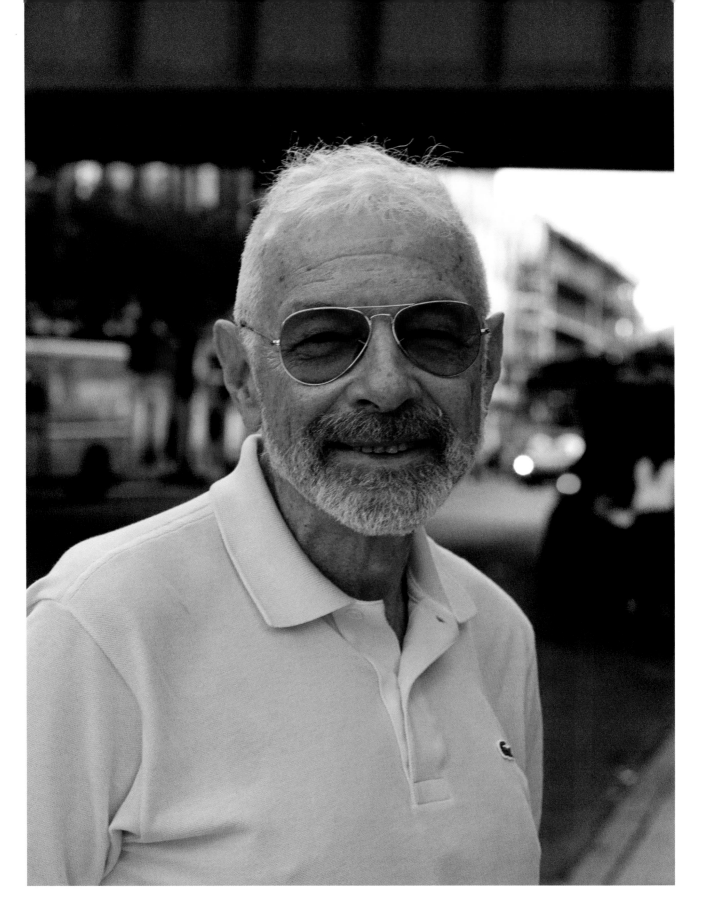

Perry Brass

I grew up in Savannah, Georgia. I was born in 1947. My father died of colorectal cancer when I was eleven years old—he was forty-two—and we were thrown into just abject poverty. My mother, my sister, and I, we ended up living in a public housing project, where we were the only Jewish family in the project. I was constantly harassed and attacked and beaten up. It was a horrible childhood. My mother had very bad psychiatric problems that we were never told about as kids. Later on, I found out that she had been diagnosed as a paranoid schizophrenic, so she could be violent, and often that violence was expressed toward me. She was also a lesbian. I think she had this horrible time with me because I was the very thing that she hated most about herself, which she repressed so badly. It was horrible, I understand that.

My father was this wonderful self-made man who was extremely supportive of me, even though we had very little in common, and he was much more the stereotypical masculine kind of guy. He liked hunting and fishing, which I hated. But he also had this vivid imagination, and he encouraged my imagination. My father and mother fought over that a lot. My mother often said to him that he was encouraging me to just go off on these flights of fancy that had nothing to do with reality, and that he was spoiling me. But he encouraged me to have this imagination.

It's very easy to mythologize your parents, and in my mythology of my parents my father can do no bad, and my mother can do almost no good, which isn't the truth. I mean, she tried to do the right thing often enough, she really did. But she also did things to me that were horrible.

In the summer of my fifteenth year, I tried to kill myself by taking a whole bottle of her tranquilizers. I stayed for a week in the hospital, and toward the end of that summer, I went through one of the great epiphanies of my life. I decided I would never let anybody drive me to suicide again. I would not let my mother do it, I would not let the kids who were saying things about me at school do it. I also decided I would be the person that I was meant to be, no matter what the cost was. I injected this healthy regard for myself into me, and it was like life opened up. The next year at school, I decided that I would completely snub all the kids who had hurt me; I'd have nothing to do with them. And I became extremely popular. All these kids, I guess they must have felt I knew something that they wanted and I wasn't letting them know about it.

It gave me a kind of jaundiced view of mankind. I started to realize that if you're warm and kind to people, and sensitive to them, they'll destroy you. If you're cold and hard to them, they'll respect you, especially straight men. That attitude got me through a lot of my twenties, but certainly by the time I got old, into my forties and fifties, I realized that that attitude was not the best attitude to have.

I believe in love at first sight. I believe that there are certain people who are just made for you. I don't know why this happens, but there's just something that happens, this click, and it's like the world opens up and suddenly you're the biggest person you've ever been. And if it closes up, you're so small that trying to keep from falling apart is very difficult. I have no reservations about the power of love. I think love is the only thing that changes human life.

Charlotte Bunch

I went to Duke University as a student, which was the best thing that ever happened because it immersed me in the 1960s, in the black civil rights movement. I always say I got two parallel educations. I got a very good academic education at Duke, and I got an education about social change from being a participant in the movement, one of the masses watching this amazing black civil rights movement. I had the good fortune to be part of the Methodist student movement, which at Duke and in many places during the 1960s was very progressive and saw part of its mission as getting white students like myself engaged in the black civil rights struggle. I was even able to go to the Selma-Montgomery march. Not as a marcher. We were assigned to work for a week in Montgomery to help find houses in both black and white communities that would take people who were coming for the march. We went out as a little team of students, nineteen, twenty, twenty-one years old, knocking on doors, and then of course we participated when the march got to Montgomery. That was life-changing for me. It really gave me a sense of what it takes, a purpose, and also a sense that change is possible.

continued >

> > >

What gives me joy is seeing people take control of their lives and do something about things they care about.

I graduated from Duke, but I decided not to go to graduate school. It was 1966, and it was like, "The revolution is happening in my country, I'm not going to graduate school, I'm going to be out there." I had this affiliation with this national and international network of student Christian movement people, so I moved to Washington, DC. I was part of a commune of people from this movement, and we worked locally on issues in Washington. I was also elected the national president of the university Christian movement, so I got to go around to campuses and try to talk to students about what it meant to be politically active and how they could do their studies in a way that would help them. We'd teach them how to ask questions in their classes. We knew that in many cases the right questions weren't being answered, and we were trying to get students to ask the right questions respectfully, not to just disrupt, but to actually try to make the professors and students

aware of questions that needed to be addressed. Some teachers loved us, other teachers hated us. I mean, it's a little bit arrogant. We were a little sassy in the 1960s.

At that time, I was a heterosexual. I didn't know myself yet as a lesbian. I really was pretty asexual, but it was the time of the sexual revolution. I married a guy from the movement, so we could be busy with our lives. We had a great political life together. It was also the best defense for the kind of sexual abuse that I think the sexual revolution produced, in terms of women being sexually harassed and thinking they had to give sex to men. Being married was, I realized later, the best way to escape that.

I became part of the first Washington, DC, women's liberation group. I was at the Institute for Policy Studies and eventually became a fellow. Its resistance to my growing feminism really pushed me to reach out to other women and get involved in women's movement activities, and I eventually decided to make that my life's work. This was the early 1970s. It was still a small movement, but there was the excitement of having all

of your life come together. I was still against the war, and I was still against all the *isms* that we're against, but I was pretty focused on women's liberation. All my intellectual and emotional friendships were with women at that point. In the course of that I encountered lesbians, and it was like a whole other dimension opened up to me. I saw this energy and excitement and joy and started asking myself, "What would it mean to allow that in my own life?" All of a sudden, all this possibility opened up and the sense that yes, this was a fuller way to be myself.

Within a year I found someone in that community that I was in love with. We had a four-, five-year, off-and-on lover relationship and then, later, a friendship that has lasted a lifetime. It was the time when everyone was still experimenting. We were feminists. Were we supposed to be monogamous or not? It got messy. I was always driven by my work, so it was like, "I don't have time for this. I want a steady relationship. I want to have sex and be in love, but I don't want to be worrying constantly." In the more non-monogamous mode, it

was like, "How does anybody get any work done?" And my work was my life.

In the 1980s, I was going to many different conferences, and that's when I met Roxanna, who was living in Peru as part of the women's movement there, and we fell in love, and spent those years trying to figure out how to be together, organizing projects. We got together in 1983, so it will be thirty-six years in August.

I decided to move to New York because I felt like I needed to do something a little bit different. I was reaching burnout. Some friends helped me find a position at Rutgers for two years as a visiting professor. They wanted to make their women's studies program more international, and I had been doing all this work for eight years, meeting women around the world and thinking about that, so I went. I was very lucky. They said let's create a center about women globally and make you the director, and I created this Center for Women's Global Leadership. We created leadership institutes for women from around the world, and we focused on women's rights as human rights. We were part of the first wave of women who were developing a feminist perspective on human rights. We created the tribunal that really pushed the United Nations to accept women's rights as human rights in 1993. That was all work we did with groups around the world, but from our base at the center. And when I say we, I really mean we. It wasn't just us. The idea that women's rights are human rights came from a hundred different places.

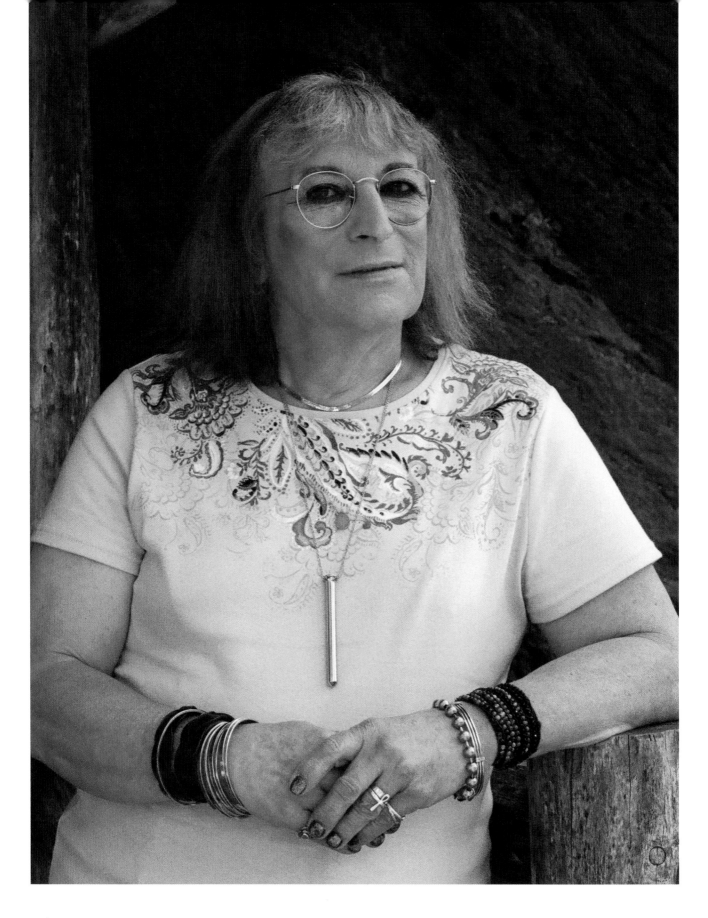

K

Karen Satin

I'm married. We were together for, like, twenty years. A lot of trans people I hang out with are in the same situation. We all ask each other the question: well, why did you get married? And we all have the same answer: because it seemed to be the thing to do. We were moving toward greater freedom, but the fact was that everybody was still very traditional. People in my generation, we all just went along with what society led us to believe was correct.

I knew I was this way when I was ten years old. That's, like, 1958. Of course, I had no idea what *this* was. I mean, I knew you couldn't tell anybody and if anybody found out, something bad was going to happen. But I had no idea what *this* was, or why, or anything. So I coasted along. By the time I got to the 1990s, I was in my forties. Nobody that was important to me knew, but I knew, and I was out partying. That worked great until my wife figured it out, and she figured the best thing to do to get rid of it was to dial 911. They put handcuffs on me, took me away, they referred me to all kinds of . . . The bottom line is they tried to cure me, and I had to go through this for a long time.

My daughter was about twelve when this happened. This was really bad news because the state came in, they grabbed the kid right away, said you're endangering the welfare of a child. My relationship with my daughter was not good for a long time. I guess she was poisoned by what my wife would say.

What brings the greatest joy to my life at this point is the volunteer work I do. I'm with the NYC Anti-Violence Project and the Center for Anti-Violence Education in Park Slope, Brooklyn. I do things like run their front desk, the crisis hotline. I have all kinds of people coming in. They can be homeless, they can be people with HIV, people who have problems. Those people have become my friends. The center is a very small organization, and so I help them with statistics or things like that; maybe they're working on their annual report or they're putting together stuff for a grant. My original background is Wall Street; I had a degree in business management, and I was an officer with various insurance companies and holding companies.

One of the things we do there is run programs for young women and trans people—and the kids can be as young as nine or ten years old. These programs are done sometimes on-premises, most of them in schools. We work to develop leaders who can then run the courses. Self-defense is part of that; we teach karate. If you're a trans person, every time you walk out the door, you could be killed and you're going to keep thinking that every time you walk out the door. The people who say they don't, they're lying. Hate is everywhere. It knows no boundaries.

You won't find a great deal of trans people at my age. A lot have died or are back in the closet. I guess a lot of people who were like me would have stopped, say, at age fifty and just kind of lived a static life after that. They never really came out or blossomed or moved beyond where they were. I tend to think that if you're going to transition now, it's easier for the young. If you're going to do it, you should either do it young or very old. Those middle years are hard.

Nelson Caraballo

I'm a Puerto Rican–Ecuadorian cha-cha queen from the Bronx. As a young gay man, I had a lot of doubts, a lot of pressure, a lot of fear, because of my conservative Catholic South American upbringing. I knew I liked boys, but it wasn't until I went off to college and I was somewhat independent from my family that I started expressing myself and coming out. And it wasn't until I got sober at the age of twenty-seven that I became true to myself. I got into trouble with the drugs and the drinking. I had my fun, but then I crossed all those lines that I said I would never cross because I had too much self-respect. When you get trapped into that, you lose total control. You think you're in control. You're not. So I cut all the drinking, the drugs. I needed to live an authentic life, as a gay man, and I came out to my parents. I was very surprised by the support that I got from my mother. I mean, she still had her little issues. I had to give her time. But there wasn't any anger. It was just a process, and today we have a better relationship.

Love is so unpredictable. You just have to not be fearful of how you feel. Don't be afraid to open up. I just had a situation where I knew someone for twenty years and we kept playing that cat-and-mouse game: "I like you," "I'm not ready." And after twenty years, when we finally reconnected, he got cancer. He went home and was in remission, and just when we were talking about him moving back to New York and maybe us moving in together, his cancer came back. He died just recently. So don't wait for your head to tell you that you're ready. Follow your heart, because you never know. Love is one of those mystical, mysterious things that when it happens, it happens, and it's beautiful. You go through

pain, heartache, ugliness, as well as the beautiful, and you can't be afraid of experiencing any of that. I know that if a situation like that were to happen again, I would be more open, rather than putting career, whatever, anything, in front of it.

One of the things that brings me joy today is people waking up and taking responsibility. We might see all this negative stuff, but right now people are saying, "You know what? We gotta change this." I'm part of Gays Against Guns, which is an organization that started after the Orlando Pulse shooting. It devastated me, like it devastated the whole community. A friend posted on Facebook, "You know, we need to get together and do something about it." And it went from like ten people, twenty people, to seventy-five people. We couldn't go to the gay pride march that year, but Corey Johnson was incredibly generous and gave Gays Against Guns his spot in the march. So we organized in less than two weeks to be part of the parade, and we marched. What we thought was going to be seventy-five people turned out to be about seven to eight hundred people. That's how all this started.

If you have a passion for something, just go for it. What other people think of you is none of your business. One of the things that I learned when I turned twenty-seven, from a guy who I didn't really like, was, "One-third of people are going to like you, one-third of the people are not going to like you, and one third of the people are not going to give a fuck. You concentrate on the people who like you, and one day you'll wake up and you'll realize you have an incredible, wonderful community, and people who love you, and that's all that matters."

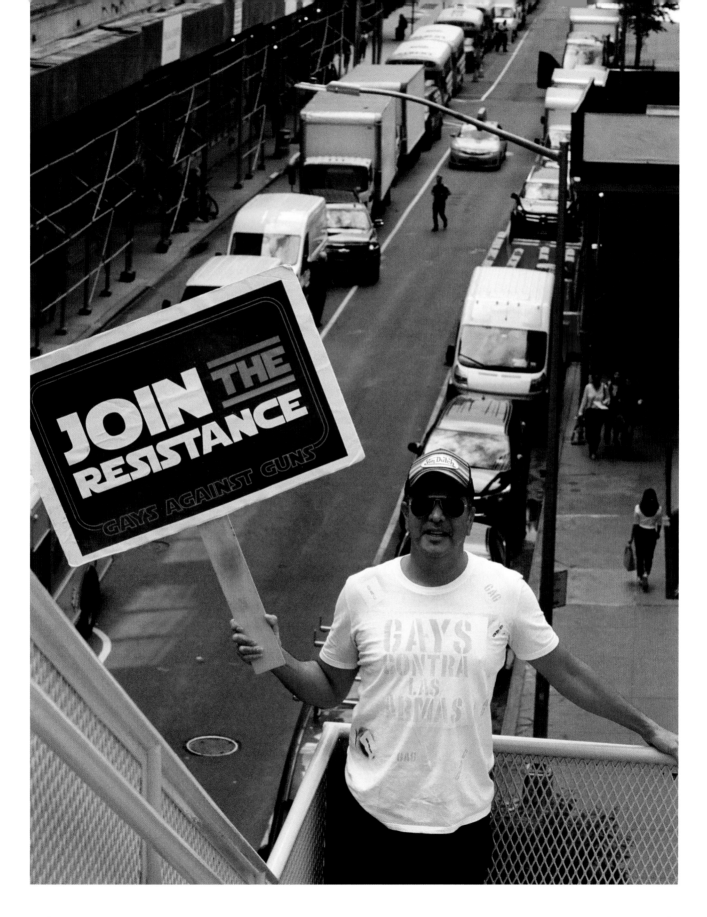

F
Fred Davie

I grew up in a small town in North Carolina, a little
textile town near Charlotte. It was five thousand people,
probably 15, 20 percent African American, the rest
white. What's interesting about the little black village
I grew up in was that, even in the 1960s, 1970s, there
were a number of out, gay, "cross-dressing men,"
several of whom were my mother's friends. It was
interesting. They were basically integrated into the
neighborhood. People made little side jokes about
them, and you didn't want to be gay or, even worse, be
called a punk. My mother, she always had interactions
and socialized with everybody, but particularly these
men—I guess they would have been men. A couple
of the guys were organists, or pianists, or musicians
for a couple of churches, and they came to church as
"cross-dressers." We used to go occasionally to parties
at these folks' houses. They were in the neighborhood,
they were in the community.

I grew up Presbyterian, so church was really crucial.
The other thing was family. We have a very close, tight-
knit family, even now, and I always have support from
my siblings, my mother. My father left the scene early
on and died when I was in my twenties.

continued >

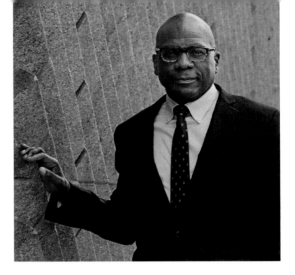

> > >

I was expected to do well in school, but I could also go out and play and party and have a good time. I had lots of friends. It was a segregated town until I was ten, and then in 1966 the schools completely integrated. I didn't know what I wanted to do for college. I thought I wanted to be a physician's assistant, so I went to this small college, Greensboro College, in Greensboro. A couple things happened for me there. One, I did well my first year, then went rock bottom first semester of my second year. A couple of professors rallied and said, "You can do this," and they set me on a good trajectory. I ended up being the first African American president of the student body, and then got the school's highest award, the Harold H. Hutson Award, when I graduated. It was huge. This was 1974.

When I graduated from there, I didn't know what I wanted to do. I moved from the physician's assistant program to political science. I'd taken religion courses that were required, and my Old Testament prof who taught me prophets, which I love, he said, "You have an affinity for this, you should go to seminary." So I ended up at a Presbyterian seminary in Richmond, Virginia, for two years. There were 354 students, and one African American at that time, and it was me.

It was the beginning of liberation theology. I told them at that school I wanted to study liberation theologies. The head of the theology department said, "This is an ideology, not theology, you won't study it here." Someone I knew who had transferred to Yale, she said, "You should consider coming here to finish your degree." I said, "I'll never get in." I had a fellowship at that time that was portable—I could take it anywhere with me—and it would pay for furthering my education. I applied to Yale and I got in, and it was the best thing that ever happened to me.

In those days the notion was that you would study at Yale Divinity School and you would probably be ordained to be a minister or you'd go into the academy, or you'd teach. But there was a movement, there had been for a while, within many faiths, where people get ordained to do social justice ministries. I built a course of study around that, and got out in the community and did a lot of community work. I came to New York, got ordained as a Presbyterian minister, but not to work in a church. I got ordained to work in the nonprofit world.

I met my first out gay man that I felt like I could identify with, this guy David Wertheimer, who was the early executive director of the New York City Anti-Violence Project. One of the smartest guys I know. And I thought, "That is an expression of homosexuality that resonates with me." I don't know why. Being gay wasn't all of David's life. He had other interests,

identities, he knew a lot about a lot of things. He wasn't stereotypical—I probably had a lot of internalized stuff to work through. I think I probably came out to him when I joined that board, and maybe I'd already come out, I don't remember the sequence. I had a girlfriend, then I had a boyfriend, then I had a girlfriend; it was a struggle. I did a sermon once on what it meant to come out, and I talked about the ways in which I had to deconstruct each of the internalized oppressive notions of identity and then rebuild a life based on who I am authentically. And then just go out and just live.

I've been in many worlds. I started out in the non-profit world, spent some time in the political world, and then decided that I wanted to do something else. I went to the Ford Foundation, ran its giving on faith-based community development. I went on to work for this major national project working with faith-based organizations and other community-based groups to provide interventions in the lives of former offenders to keep them from recidivating. It got me involved in Obama's presidential campaign, and we helped draft a speech for him, the faith speech he gave July 1, 2008, in Zanesville, Ohio. When he got elected, I was on the transition team, did agency reviews for the faith-based programs, and I was appointed to the council of the White House Office of Faith-Based and Neighborhood Partnerships.

I had stayed in touch with a friend from Yale Divinity School. She was invited to be the president of Union Seminary, and she asked me to come and work with her, and now I'm beginning my ninth year at Union.

I had one long-term relationship, with an Episcopal priest, but he and I broke up in 1998, after eleven years. That was very hard. And then Michael and I got together shortly after that. I resisted it like crazy, but he was determined. And twenty-one years later we're still together, which is really great. We met at a mutual friend's house, at an afternoon lunch, on New Year's Day. But then we didn't see each other for seven months. He kept making these overtures through our mutual friend, and I kept resisting. One day I gave in. I think I'm made for a relationship. I'm just a much better partner than I am by myself.

When I was working on setting up the Office of Faith-Based and Neighborhood Partnerships, the people next door, whom I got to know really well, were planning the president's inaugural worship service. It happens just before you go to Capitol Hill for the inauguration. So they said the president-elect and the first lady would like for you and your partner to join them as their guest at the worship service. We went to the worship service, and we were in the motorcade up to the Capitol for the swearing-in, which was just simply amazing and very moving. Michael was really impressed. He said, "I knew we were going to church at 4:30 in the morning, but I didn't realize it was going to be anything like this."

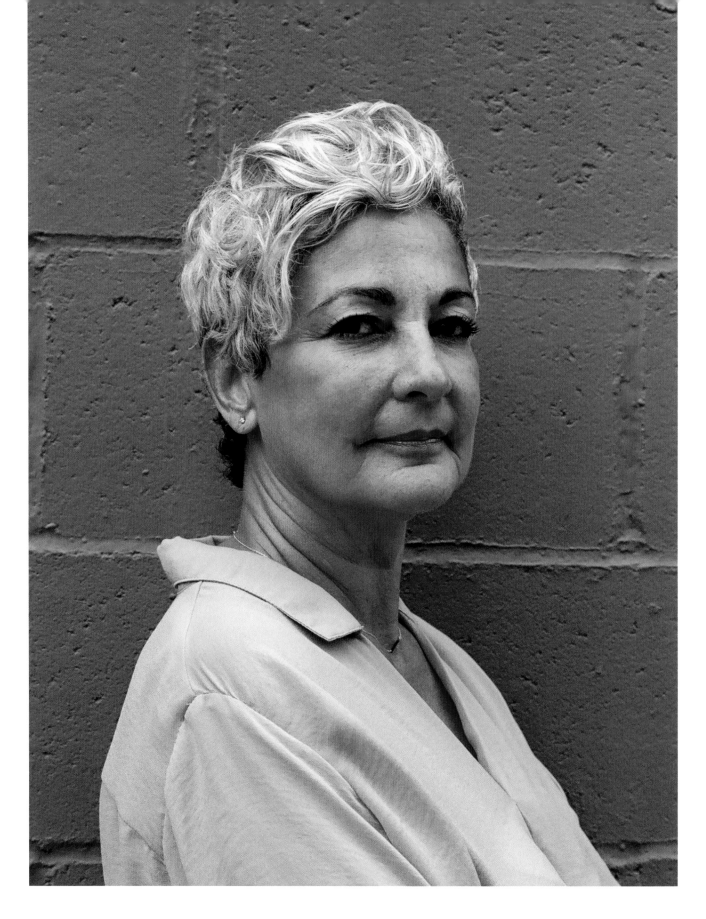

Wanda Acosta

My sexuality, it used to be lesbian, or it is lesbian, but more and more I like queer because it doesn't feel so much like a sexual identity. It doesn't have to do with who you're sleeping with. It's more rounded, it's a way of living your life, it's a way of thinking out of the box, it's not conforming to social norms. That fits me more comfortably.

I was born in Brooklyn. My parents are from Puerto Rico. I realized that I was a lesbian, gay, queer person when I was in my twenties, although I was attracted to women from an earlier age. I got married to a man when I was twenty-five. I met him when I was twenty, and we divorced when I was twenty-eight, and all along, I was having things with women. It was my secret.

When we divorced, I realized that I needed to explore who I am. Nobody really knew except the friends that I was really close with—a few women, but mostly gay male friends. And so I was having a conversation with my mom on the phone, and she was concerned because I wasn't dating any guys. She asked me, "What did you do this weekend?" I told her what I did, and she was like, "I don't understand, Wanda. Why do you have so many gay friends? Why are you going to so many gay clubs?" I was already so tired of keeping that secret, it was eating me up inside, so I just said, "Mom, because I'm gay too." That was devastating for her. It was a long conversation, lots of tears, but we worked it out over many years. It wasn't easy, but it was a complete liberation for me to be able to tell my mom.

At that time, I realized I couldn't identify with the lesbian spaces that were available to me in New York. They were dark, they were in the back of some basement, it felt depressing to me because I had been hiding so much. Now that I felt free, I wanted to be out, I wanted to be visible, I wanted to dress up and look fabulous, and I wanted a place to have a drink and invite my friends. But that wasn't available in 1993. So, a woman I was seeing at the time and I, we started talking about maybe doing our own thing. We approached this restaurant in the East Village that was super popular, and we said, "Hey, we want to do a lesbian party here. Would you be interested?" And the owner said, "Give them a chance. Let's see what they can do, and tell them only Sunday's available." That was their dead night. We were like, "Okay, great."

The party really took off. The first night we probably had about one hundred people, but they were the most amazing people. Then everybody started coming. The women dressed up, and it was like a runway every Sunday. The media jumped on that. It changed how the world, or at least New York, viewed lesbian women, and lesbians changed how they wanted to present themselves. From there, I opened gay bars in the East Village with some partners. I had three bars, and they ran for ten years. But in 2008 we closed our last space. Our lease ran out. It was hard. The banks crashed, the businesses, gentrification.

At this time in my life, being in Puerto Rico and being in nature just brings me the greatest joy, to see the swaying palm trees or the birds or being near the ocean and seeing the ocean every day. Also, spending time with my partner, spending time with my dear, dear friends and family. The idea of love changes as you grow, and for me, the idea of love, at this age, is a very calm love. It's something that's mutual, that's honest, that's without judgment, that's compassionate, that's communicative, that's expressive, that's sometimes unsaid. You don't need to have all the other stuff to know that a person loves you. ▬

Afua Kafi-Akua

I'm a born-and-bred New Yorker. I was born in the Bronx, and I grew up in the Bronx until I was around twelve, twelve-and-a-half, and then we moved to Queens. I'm a mixed-media artist. I mix photography, film, music, spoken word, and video together in installation pieces. I print photo collages and photographs on metal or canvas.

My parents wanted me to be a doctor. I have a BS in psychology and was pre-med at Howard University. As a Caribbean family, they were like, "Well, we gave you all these arts that were supposed to enrich you, but you're not supposed to become an artist."

I remember, when I was in kindergarten, I had a crush on this girl. But I also had crushes on boys. When I was in junior high school, I had boyfriends, I dated boys. Got to college and had boyfriends, and my graduation gift from college was a child. I had a child. I think I was twenty-two by then. While I was in Washington, DC, I became pen pals with Nona Hendryx. That helped me as an artist because I would send her cassette tapes and she would critique my work. I just thought she was great. When I came back to New York, we met in person. She had left Labelle by then. I started going to her solo shows and I said, "Well, what is this attraction I'm feeling?" Little by little the crush wore off, and I got to know her as a mentor and friend. During that time I was also sorting out my feelings about my sexuality. She had a really large gay and lesbian following. I was feeling conflicted about who I was, and I met a lot of women who were lesbian and out—literally. I ran into this woman who lived down the hall from me in a dorm at Howard. And said like, "I think I had a crush on you." So I asked her out. It didn't turn into anything though. Just friends. Coming out for me wasn't painful, it wasn't anything. I just felt like this is who I always was. I wasn't like, "Oh, no, my goodness, I'm gay! What's going to happen?" I just kind of floated right out and one day I was like, "You know, I really am, I'm feeling comfortable with this community."

When I came out, it was interesting. It was a little difficult, being an Caribbean-American woman. My parents and some of my family members weren't that into it. I was confronted by my mother. She asked me, was I a bisexual? And I said, "No, ma, I'm a lesbian." It became an interesting divide between us. Prior to that—myself and my son's father weren't together—she'd be, "No, you'll meet somebody else, and you'll have a wedding at some point down the line." Once I said I was a lesbian, my father was like, "Well, what can a woman do for you?" "Well, Dad, what does a woman do for you?" That didn't go so well. But they changed. It took them maybe fifteen years. It was kind of tough. But I learned that even though they didn't approve, my family could love me, they could love me in their disapproval. No one ever cast me out and said, "You gotta leave." I have friends who were kicked out of their houses. That didn't happen to me.

I fall in love all the time. It'll stick eventually. I feel like there's somebody out there and something will come. I have great friends, and I love all my friends. We support each other, and I always feel their support. I feel loved. I feel like I have a loving community. And I have had some wonderful women in my life that I've loved deeply, that I still love today because they're wonderful women. I'm a romantic, I'm a Leo, I love. ▬

JM

Michael Bennett

Juan Battle

Michael (right): I grew up in Pullman, Washington. I grew up in the pea-and-lentil capital of the world. We had a lentil festival. There is a lentil queen. I went to college in Walla Walla, Washington, the town so nice they named it twice—Whitman College. And I got married there, after college, to a woman I knew in high school, and we were together for eight years. Moved together to the University of Virginia. To make a long story short, I started grad school married to a short white woman, and I ended up married to a large black man.

Juan (left): Graduate school is a space of self-discovery.

Michael: We met at a conference at the University of Illinois, Urbana-Champaign. I was in grad school in Virginia, he was in Michigan, and we did the long-distance thing for a while. Here's the weird part of the story: when I met Juan I found out he's going to Michigan, and I said, "You've got to be kidding me." My ex-wife had decided she was going to the best pharmacy school in the country, which was in Michigan. For a period of time my ex-wife and current boyfriend were living a few blocks from each other in Ann Arbor, and I was still in Charlottesville. He actually helped give her advice on where to stay, and we're all good friends.

Juan: I was raised in the Washington, DC, area. A large family, both nuclear and extended family in DC, very working class, working poor. I was fourteen when I came out. My mother says I discovered I was gay at lunch and by dinner everybody knew. It wasn't this sort of being in the closet and wrestling with it. It was embracing it and running with it, and I was a club kid, you know going to clubs in my teen years and in my twenties, and that kind of thing. I wasn't in the drug scene. Be hard to make it through college with that. It worked out, and then we came to New York in 1994, and I've been at CUNY my whole career.

Michael: We have very different experiences. I grew up in a small town with a small white middle-class family, and I'm an only child. We often said that we probably would not have hung out at all in high school. We would have not known each other at all. I came out late.

My political education was very important to me. The main thing I got involved with in Charlottesville was the divestment from South Africa movement, and we were able to move the state to divest a billion dollars from South Africa. That gave me a lesson in the power of a few people to change policy and make things different. Anything that was left in Charlottesville, I was

continued >

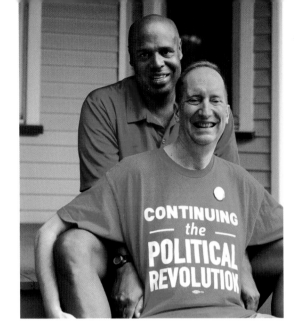

> > >

involved in. I joined Democratic Socialists of America, Queer Nation, Earth First, the UVA Rainbow Coalition, any lefty group.

When I got divorced I moved into an apartment, which is where I was living when I met Juan. It was a little lonely, except when Juan was there, so I decided to move into a house with three gay men, and so it was my socialization in living as a gay man, with other gay men, in a house. One of my housemates was HIV positive. He had been for a long time, so even though the new drugs had started to come online, it was a little too late for him. Then there was this other guy, but those were the only two people I knew who died of AIDS. That's unusual for someone of my age because I basically skipped the 1980s.

Juan: In the 1980s, I was in DC, and people were literally dropping like flies. With AIDS, the narrative that we're used to is what happened to white America, which is the gay narrative. But for black folks, it was every story you've heard, every documentary you've seen, it was just fucked up. And because I grew up in a black church, and if you're tall and articulate and a male, someone's going to give you a mic at some point. Little thing called male privilege. And so I started preaching, got ordained. Also, death was bigger than AIDS in the black community. Violence was a big thing. Gun violence, crack, in the 1980s in the Washington, DC, area. Poverty-related illnesses and disease.

Then I found myself in Michigan, in 1990, and basically where white America was and the coasts were concerning HIV in the mid-1980s, the Midwest, specifically Detroit, was a good five to ten years behind that. I quickly tapped into the black gay community, and people were dying. What we now call the AIDS panic in the black community was crazy. At the time, there was one black funeral home that would bury people who died of anything that even smelled like AIDS. You could bring a twenty-three-year-old male and say he had ovarian cancer, they'd bury him. If you said he had a cold or anything like that, they would have funerals where there would be ropes up because people thought that if you touched the body, you would get the disease, like Ebola. I started doing funerals and was doing, you know, two and three funerals a day. I was in my early twenties. Then we moved to New York, where there was a huge network in place, an infrastructure of support, and it was with a level of joy that I stopped doing funerals.

Michael: We both are extremely grateful that we survived and are here, and are able to do good work. We're not as interested in any kind of mainstream gay stuff. So like, marriage and military, I don't really fucking care that much. I'm just saying that for us, it's all about seeing sexuality as tied up together with race and class and gender and a whole host of things. We're not so interested in mainstreaming gay folks as we are in queering the mainstream.

Juan: Love wins. That's what I know for sure about love. And if it looks like it didn't, it's because the game ain't over yet, keep playing. To me love is a behavior. It's what you do. Not how you feel—like is a feeling, infatuation is a feeling. I don't give a shit how you feel. How do you behave, how do you act? Love is giving, lust is taking. And I think any of us would give that comfort, I would hope, unless you're a psychopath. And then I'd get you some help.

Michael: For me, the reason I'm a socialist, social politics is the organized expression of love, that you care about people having access to the same rights and responsibilities and possibilities as everybody else, regardless of sexual orientation, regardless especially of class.

These days, I think the question we should be asking is not what can people teach younger people, but what can we learn from them, because right now younger people are more likely to support socialism than capitalism, they do not define themselves in the conventional ways in terms of gender or sexuality. They have taught me, definitely, to think differently about all kinds of things. One of the things that older LGBT people need to do is learn from younger LGBT people. ▬

Acknowledgments

The photographs presented in this book were made possible by
Jon Stryker: philanthropist, architect, and photography devotee.

This book was made possible in part by a grant from the

Many people took part in this project, but special thanks must go
to Juan Battle who was instrumental to the conception of the book.

When you listen to so many life stories, you realize how much of a
challenge life can be. The journeys of the people in this book showed
the beauty of life, from overcoming loneliness, pain, sadness, and loss
to accepting who they really are and acknowledging their strength
and determination when it comes to the way they have chosen to live.
I feel so honored to have had the opportunity to hear these voices.
Their words are a reminder of how acceptance and forgiveness,
without judgment, can raise the consciousness of society.

—Delphine Diallo

*The Arcus Foundation is a global foundation dedicated to the idea that people can live
in harmony with one another and the natural world. The Foundation works to advance
respect for diversity among peoples and in nature (www.ArcusFoundation.org).